Calligraphy
A to Z

A new technique
for learning the basic hands
Step-by-step exercises

alligraphy A to Z

by Stuart David

Stravon Educational Press New York, N.Y.

THANK YOU

Sherry Morse, Sigfried Heiles
and Morton Garchik
for all your help in preparing
Calligraphy A to Z.

Copyright © MCMLXXXV
By Stuart David
All rights reserved

Library of Congress Cataloging in Publication Data

David, Stuart.
 Calligraphy A to Z.

 1. Calligraphy. I. Title.
Z43.D243 1984 745.6'I 84-16380
ISBN 0-87396-088-2

Reprint 1986

Manufactured in the United States of America

CONTENTS

5

ITALIC CAPITALS

ADVANCED FORMS

APPENDIX

PREFACE

BEFORE the invention of the printing press, all books were lettered by hand. The press put the scribe out of work. This was the beginning of mass production in which a machine replaced the manual labor of many people. The books produced by machine rarely had the quality of those produced by hand. This deficiency was generally overlooked because so many more books became available to readers.

However, toward the end of the 19th century, a reaction against the quality of machine-made goods sprang up in England. The old crafts were revived, including calligraphy.

A century later the interest in hand-crafted products continues to grow, even in the midst of the advanced technology of 20th-century America. Practicing calligraphy has become increasingly popular as a hobby. There are several reasons for its popularity.

1. It can be learned by anyone who knows how to write. It is not necessary to study a new skill, but merely to refurbish one that is familiar.

2. It does not require "artistic" talent. Most calligraphers have never been to art school. All you need is an appreciation of beautiful writing and a willingness to do the necessary practice.

3. Results—and satisfaction—come fairly quickly, even for someone who "can't draw a straight line." With an hour's practice every day, most students can change their handwriting remarkably in two to four weeks. Of course this is only the beginning. Serious students spend several years in developing proficiency.

4. Learning calligraphy is not expensive. Start-up materials can cost less than $15.

5. Calligraphic pieces make wonderful gifts. Poems or prayers written in decorative script are often framed and displayed as

cherished possessions. And the services of a calligrapher are highly valued by any club, church group, or service organization.

6. Moreover, it can produce an income. Beginners may try their hand at addressing envelopes for weddings, filling in names on certificates, and making small signs. More advanced calligraphers are paid to design invitations to special occasions, menus, and scrolls. For those who enter commercial art as a career, there are headlines for advertisements, logos, book covers, record jackets, and other designer items that utilize elegant or distinctive handwriting.

There is one further benefit that is not often discussed but is acknowledged and enjoyed by many practitioners. It is that the time one sets aside for the practice of calligraphy can become a peaceful period in the day to put one's cares at a distance and calm one's thoughts. It is a practice that settles the mind. In a clean, well-lighted space, with tools and materials neatly organized beside the drawing board, the calligrapher enters an island of orderly quiet. In a balanced, erect posture, with feet flat on the floor and a relaxed grip on the pen, the calligrapher attends to the flow of ink between pen and paper and discovers a new kind of adventure.

Preliminaries

All
should be taught
to write
a fair hand,
and swift,
as that is useful
for all.

B. FRANKLIN

INTRODUCTION: THE GEOMETRY OF CALLIGRAPHY

T HE method of calligraphic instruction offered in *Calligraphy A to Z* is based on the internal structures and the basic strokes of letter forms. The most basic structures are geometric and the most basic strokes are the straight line and the circle. There are three reasons for the development of this method: (1) The principles of geometric construction were used to create the letters of the Western alphabet. (2) Learning calligraphy by this approach is easier than by the usual letter-by-letter method and takes less time. (3) The student learns about letters from the inside out—literally—starting from the internal structure and adding on the external form. These reasons may be elaborated as follows:

(1) *HISTORICAL*. There is an ancient Greek legend about the origin of the alphabet. It was first told by Ovid and then retold by Geofroy Tory, a scholar and type designer of the Renaissance. Jupiter fell in love with a young girl named Io, but ended the affair by turning her into a cow. After some unhappy adventures, Io made her way home and found her father. She could not speak to him but pressed her hoof into the soft ground and left the imprint *I* and *O* by which he recognized her. That land became known as Ionia. Historically, Ionia was the city-state which created the version of the alphabet that became the official version for Greece in 403 B.C. Geofroy Tory maintained that from the letters *I* and *O* all the other letters are made and fashioned.

To understand this statement and to appreciate the importance of the *I* and *O,* we must look at the contribution the Greeks made to the alphabet. The Western letter forms were gradually developed over several centuries. In Greece, the last vestiges of the hieroglyphic image dropped away and were replaced by an abstract, geometric look. In his book, *The Living Alphabet,* the contemporary type designer and calligrapher, Warren Chappell, attributes to another

11

famous contemporary calligrapher, John Howard Benson, the observation that "...Euclid's word, στοιχειον, which is translated as *element,* is the same as the common Greek word for *letter.* Thus geometric elements and letters have a common identification...the alphabet is a series of improvisations on geometric elements." Geometric forms are drawn with the point, the straight line, and the circle. So are letters. The straight line and the circle are the *I* and *O* to which Geofroy Tory was referring.

The straight line and the circle continue to be important in the design of today's Roman letters in both typeface and calligraphy. In his book, Chappell notes, "An understanding of the twenty-six letters as simple geometric archetypes is the key to providing the imagination with a set of armatures on which to model the forms, as individually as a sculptor might model a figure in clay." *Calligraphy A to Z* takes its starting point from these two geometric elements. As they are the basis for the creation of the Roman letters, so can the student use them in learning to draw these letters. The two elements used in the Italic letters are the straight line and the condensed circle, the oval.

(2) *PRACTICAL.* Calligraphy is usually taught letter by letter. There are about 70 different forms to learn: the 26 small letters and the 26 large letters of the alphabet, the numerals from *0* through *9,* and an assortment of punctuation marks. They are explained one at a time, *a* through *z, A* through *Z,* etc. This is like asking a young art student to learn to draw 70 different objects (Fig. 1).

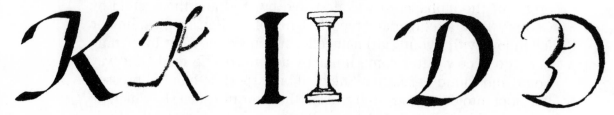

FIG. 1

In *Calligraphy A to Z,* the student is presented with the two structural elements that are used in all of the letters, numerals, and punctuation marks. In the Roman style of writing, the two elements are the straight line and the circle. In the Italic style of writing, the two elements are the straight line and a condensed circle, the oval. To begin with, these elements need not be drawn precisely. They may be loosely sketched, much as a child draws a stick or a ball using a crayon (Fig. 2).

FIG. 2

The next step is to join these elements—line and circle, or line and oval—into combinations that produce the basic strokes. In the Roman style, there are 10 basic strokes (Fig. 3a). In the Italic style, there are 13 basic strokes (Fig. 3b). As every letter, numeral, and punctuation mark is made up of one or a combination of these strokes, the student only needs to learn 10 or 13 basic strokes, not 70 different forms.

FIG. 3a

FIG. 3b

(3) *AESTHETIC.* In the "70 Form" method, students learn the *external* forms from a book or their teacher's sample letters. In copying these letters, the students try to render the outward likeness of the sample forms (Fig. 4) without any knowledge of Chappell's "geometric . . . armature on which to model the forms." In the "basic-stroke" method, students learn the *internal* forms, the structural elements which all the letters have in common and which run a unifying influence through their diverse appearances. The basic strokes are like the "bones" of a letter; this approach is like studying anatomy before attempting figure drawing or like learning scales before playing a melody. This presentation of structural analysis may also prove helpful to advanced calligraphers who wish to refine their letter forms.

(4) *OTHER FEATURES.* Several other features distinguish the learning approach used in *Calligraphy A to Z.* The lessons are

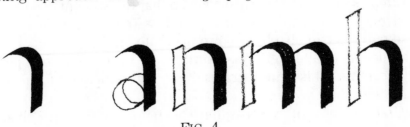

FIG. 4

arranged so that it is easier to learn the later lessons from what was learned in the earlier ones. The strokes of the small Roman letters are the same strokes that are later used in the large Roman (capital) letters and the italic uses a variation of the strokes already learned in the Roman (Fig. 5).

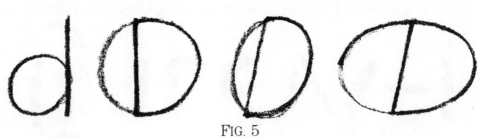

FIG. 5

Students learn more easily when they use large size pen nibs or markers. Therefore, the exercises have been done with a large nib and the student can practice in the same size shown in the examples. Wide-ruled pads are recommended for use because their blue lines are the same distance apart as the guidelines used in this book. As the exercises are done stroke by stroke, comparisons may be made each step of the way. The direction each stroke is drawn is indicated by an arrow.

No exemplar sheet of letter-perfect forms is presented. Students can be intimidated if they are asked to copy very sharp, finished forms. Samples of letters appear in the lessons and full alphabets appear in the Appendix, but it is not intended that students slavishly duplicate these letter forms. Students should learn the structural basis of letters, be consistent in executing their forms, and let their own styles develop.

All the exercises are first done in pencil, because this is a tool with which students are most familiar. This will allow them to practice the actual structure of the letters during the time it takes to become comfortable in handling a pen. In any case, a pencil is useful in its own right. One of the aims of calligraphy is to improve handwriting, and most of us write with a pencil or a ball-point. (See Lesson 23, Handwriting.)

Examples of borders are provided so that the student can practice the strokes in less intimidating exercises than in forming letters. These borders can also be used to decorate pieces.

The details of all letter constructions are drawn with two pencils taped together. This demonstrates the structure of letter forms more clearly than do inked letters.

METHOD. The pen exercises have been done with a Speedball C-1

nib, using Stephens Calligraphic ink on Hammermill Bond paper at the same size as the reproductions. Sandarac was rubbed into the paper before inking. (Sandarac is a resin which is ground into a powder, poured into a cloth sack, and dusted onto the surface of some papers to give them added tooth and sharper hairlines.)The pencil exercises were done with an Eagle Prismacolor 944 Terra Cotta. It was chosen for its grainy contrast to the sharp inked letters.

TERMS. There are several styles in calligraphic writing. Each style is called a "hand." The hands presented in this book are the basic Roman and the basic Italic. These hands can satisfy most of the calligrapher's needs: from improving handwriting skills to executing commissions for profit. Over 80 percent of all commercial calligraphy is done in one of these hands.

The Roman hand gets its name from the capital letters developed and used during the ancient Roman empire. The lower case letters were added later and derive from the Carolingian hand which was developed in the Middle Ages. During the Renaissance, the Roman capitals were combined with the Carolingian lower case to produce the "Bookhand," so named because it was used in the writing of books. At the beginning of the 20th Century the English calligrapher Edward Johnson revived this hand calling it "The Foundational Hand." This is the style on which our most common serif type faces are based. In the printing trade, these seriftype faces are loosely referred to as "Roman." "Roman" is the term used in this book as it is so commonly used and generally understood for this hand today.

The terms "upper case" and "lower case" are also used in this book for reasons of common usage. Big letters and small letters were called respectively *majescules* and *miniscules* during the Renaissance. Today, calligraphers (and for that matter almost everyone else) say "capitals" or "upper case," and "lower case." The latter two terms came into use during the early days of typesetting when each letter was made of a single metal slug, similar to the letters in a typewriter. The big letters were housed in one wooden case and the small letters in another. Since more small letters are used in the makeup of a page, their case was placed on the lower shelf for easier access to the typesetter—hence—lower case. The capitals were placed on the upper shelf—hence—upper case. The term "small letters," however, is still in use in elementary and secondary schools.

THE "FIRST LESSON"

THE first time you take a broad-edge pen to paper is your "first lesson" in calligraphy. Your learning begins by observing the ink line undulating across the paper like the unfurling of a black ribbon. For as many years as you practice calligraphy, you will continue to learn by following the progress of that line. The quality of attention you give to a practice is self-taught but instruction can be given on the way to approach the practice.

POSTURE. A professional typist is an excellent model to follow for a comfortable sitting posture—balanced and erect. The medieval scribes pictured in old woodcuts have a similar posture. Improper sitting positions can cause backaches and impart a tension to your work: a cramped posture will cramp your style. Check your own posture by taking a deep breath. If the breath comes easily and naturally, your posture is fine. If your breath is constricted, straighten up, stretch, and start again.

WORK TABLE. Your posture depends to a great extent on the kind of work table you use. An artist's drawing board is the ideal work table as it can be inclined at any angle. Such tables are too expensive for most students. A satisfactory surface is made by propping up a board at a comfortable angle against a stable object, such as a fat dictionary. Make sure it is firmly in place. If the board wiggles, it will distract you from giving full attention to the work.

GRIP. The way you hold your pen—your grip—like your posture, must be relaxed. Brute force will not make you a winner at calligraphy, so don't grit your teeth and squeeze your pen tightly to "get it right." Keep your tongue inside your mouth. If your pen hand is constantly becoming tense, put a pencil in your other hand and touch the eraser end just above the line you are writing. This will have the effect of "grounding" the tension and leave your pen hand loose.

LIGHTING. Before you begin to practice, provide yourself with a

16

light source that does not cast shadows from your hand or your body onto the working surface. Also be sure that there is no glare on your work.

LAYOUT. When you see a finished piece of calligraphy, even before you read the words, you may like or dislike its overall look. What you are responding to is the relationship of the mass of words to the white page. All of us know about balance or imbalance as it appears in art or nature; it does not have to be taught. The student can begin practicing the balance between words and white space from the very first practice sheets. This is done by providing ample margin space around the lettering on both sides, top and bottom. Try different layouts and compare them to refine your sense of design.

If you use wide ruled pads for practice (this will be discussed in Lesson 2), you will notice the pages have red margins printed down the left side, 1 1/4 inches from the left edge. Draw in pencil a parallel margin down the right side of the page, 1 1/2 inches from the right margin. The top margin crosses the page 2 inches from the top; draw a bottom margin in pencil 2 1/4 inches from the bottom.

You may experiment with these measurements, but always leave sufficient breathing space around the work. Some beginners feel the practice sheets "don't count" or feel they do not want to "waste" the paper. Do not make this mistake. This practice will develop your sense of design and provide the satisfaction of pleasing layouts long before you are able to control the letter forms.

EXERCISES

When you learn letters by strokes, several lessons are needed before the different strokes can be combined to form letters or words. But you can plunge into the whole alphabet now if you like. In fact, it is recommended.

Figure 6 has all 26 letters in it. Copy it a few times as well as you can, then, after you have progressed through several lessons in this book, copy them again, to discover how much you have learned. Such repetitions will record your progress in calligraphy.

The quick brown fox jumps over the lazy dog.

FIG. 6

TOOLS OF THE CRAFT

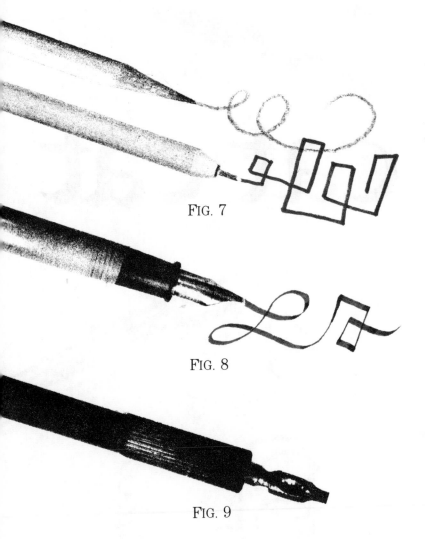

FIG. 7

FIG. 8

FIG. 9

L ET us come right to the point: the point of the pen. The pen generally used for handwriting at present is the ball-point, which makes a line (Fig. 7) like that of a pencil. No matter in which direction this line is drawn, it maintains a uniform thickness. The calligraphy pen does not end in a point, but an edge, and so it is sometimes called a "broad-edge pen" (Fig. 8). The line it makes is thick or thin depending on the direction in which it is drawn. Its writing end is called the *nib;* the part holding the nib and held in the hand is the *barrel* (Fig. 9).

The broad-edge pen has a different feel from that of a ball-point. It may be a while before you can handle it comfortably. The exercises in this book are done first in pencil and then in pen. Copy the pencil exercises to learn the letter forms with a familiar instrument; when you have grown accustomed to the pen, you can dispense with the pencil.

There are other writing tools that are broad-edged and have a softer touch and smoother glide than does the metal nib. You may find them helpful to use at the beginning. They are easier to control and they produce larger letters than do the small metal nibs. This has an added advantage for the beginner. You may hide mistakes (from yourself) in small letters, but large letters show you just what you have done.

The best tool for the beginner is a chisel marker with a firm tip. It comes in several sizes (Fig. 10) and colors. Experiment with different sizes and colors in the same piece. You will notice that the lines drawn by the marker are not as sharp as the lines in the exercises in this book (Fig. 11). A pen was used because an ink line reproduces more clearly in the printing process.

Another excellent learning tool, already referred to in the Introduction, is devised by connecting two pencils with tape or rubber bands. Working with twin pencils allows you to see very clearly how the strokes of the letters join together (Fig. 12). In the Appendix you can examine the construction of all the letters in both the Roman and Italic hands, as drawn by twin pencils. Practice all the exercises not only with the pencil and broad-edge pen but also with twin pencils.

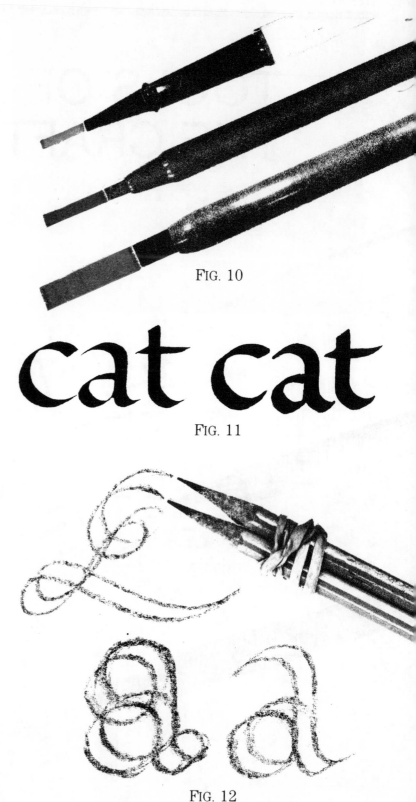

FIG. 10

FIG. 11

FIG. 12

FIG. 13

Chalk is another excellent learning tool. When calligraphy teachers make demonstrations at the blackboard, they produce such beautiful letters (Fig. 13) that the students want to applaud. The teacher may be a wonderful calligrapher but the chalk helps a lot—it handles so easily. Students should get the same benefit and use this tool, too. The tip of the chalk can be used for the pencil exercises and the side for pen exercises.

If you start your learning with a broad-edge pen, use a large nib. The wider the nib, the larger the letters should be. Here are the usual proportions between nib size and letter height (Fig. 14):

Lower-case (small) letters as high as the letter x for both Roman and Italic are five nib-widths high. This is called the x height. Letters with ascenders (such as h or b) or descenders (such as g or p) have three additional nib widths. Capital letters and numerals are seven nib-widths high.

To draw letters *exactly* to these proportions requires drawing the "ladders" of 3, 5, and 3 nib widths, transferring these dimensions to plain paper and drawing guidelines with a T-square. For maximum results this operation requires special equipment, and the instruction of a teacher, but you can draw

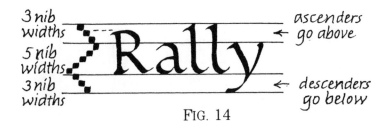

3 nib widths
5 nib widths
3 nib widths

ascenders go above
descenders go below

FIG. 14

letters *close enough* to these proportions with ruled paper, in pads or looseleaf. These sheets have a good surface for either pen or marker. Ruled paper comes in three kinds (Fig. 15): narrow, college, and wide. The exercises in this book were done on wide rules. It would be helpful if you use the nib size and guideline spacing that are used here.

If you cannot get the same nib size used in this book, you can find the correct ruled paper in the following manner: Draw the "ladder" of five nib-widths with the pen you are using. Compare the height of these five nib widths with the distance between the blue lines in the three pads. Choose the pad with the lines that most nearly match its height.

You will find in the Appendix, axis sheets marked Roman and Italic. When you are drawing Roman letters, place your ruled paper over the Roman axis sheet and line up all the letters along the vertical lines, which will be visible through your ruled sheet and the sheet you are working on. When you are drawing Italic letters, use the Italic axis lines; they will help you slope all the letters at the same angle. There are also sheets in the Appendix with both guidelines and axis lines, for use under plain (unruled) paper. The guidelines conform

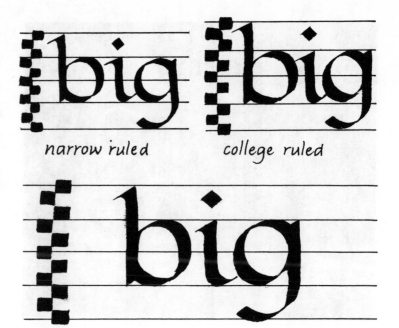

narrow ruled college ruled

wide ruled & recommended marker size

FIG. 15

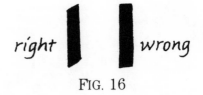

right wrong

FIG. 16

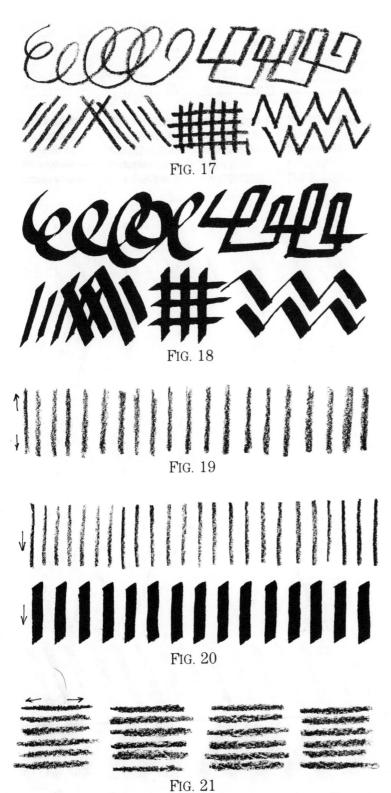

FIG. 17

FIG. 18

FIG. 19

FIG. 20

FIG. 21

to those used in the exercises.

When using pen and ink, put several sheets under the paper on which you are working. Try working with and without this cushion, to feel the difference. Also keep a piece of paper under your pen hand. Your skin has a certain amount of oil. Ink has a water base. Oil and water do not mix. If your skin oil rubs into the paper on which you are working, you will not be able to draw a clean ink line over it.

As you work, hold the pen at a slight angle. Your vertical lines should have a slanted top and bottom (Fig. 16). As for the angle of the slant, at this stage you need not be too concerned; no one is going to rush out to test it with a protractor. Tilt your paper slightly to the left. Lefthanders tilt their paper to the right so that the top edge is nearly parallel with the right side of the writing table. Keep sliding your page, as you work, so that the line you are writing is immediately in front of you. If you have to reach up, down, or over, it will affect the angle at which you are holding your pen.

In drawing a vertical line in pencil, you can stroke from top to bottom or bottom to top. With the pen, all strokes are drawn down, from top to bottom. (The rare exceptions, where the pen is pushed up from bottom to top, come at the end of the book.) In all of the exercises,

the direction that the pen is drawn is indicated by an arrow, and numbers indicate the sequence of strokes.

Above all, relax. If you feel any tension in your hand, hang it by your side and relax it. If you adhere to this practice, no matter how often you have to stop work, relaxation, rather than tension, will become part of your work habits and it will reflect in your calligraphy. So make it easy on yourself. Relax.

EXERCISES

1. With a pencil, draw a continuous line: up; down; all around. Draw disconnected lines in any direction. Notice that the moving line does not change in thickness (Fig. 17). Now follow these same procedures with the broad-edge pen. Notice how the moving line changes from thick to thin (Fig. 18).

2a. Draw a series of "sticks." They can be rough. Move the pencil up and down several times until the "sticks" feel vertical (Fig. 19).

2b. Draw a series of vertical lines with pencil and with pen in a single downstroke (Fig. 20).

3a. Draw a series of horizontal "sticks" (Fig. 21).

3b. Draw a series of horizontal lines in one stroke with pencil and pen (Fig. 22).

4a. Draw a series of diagonal "sticks" (Fig. 23).

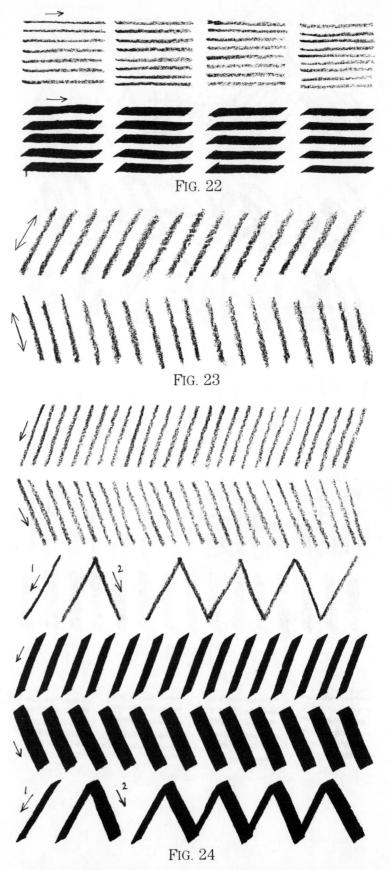

FIG. 22

FIG. 23

FIG. 24

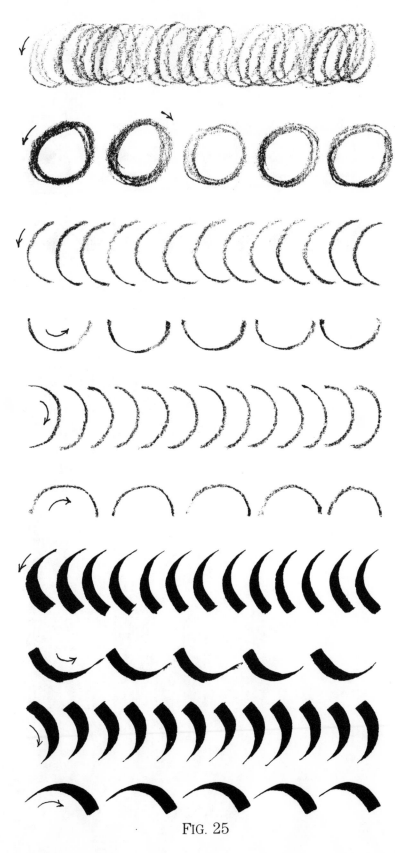

4b. Draw a series of diagonal lines in one stroke with pencil and pen (Fig. 24). Notice how the thickness of the pen line changes as the angle changes.

5. Draw pencil spirals and balls, both clockwise and counter-clockwise, to loosen up. Then draw curved lines, at first with pencil, then with pen (Fig. 25). Several of these exercises—vertical and horizontal line, balls, and spirals—can be used as warm-ups each time you sit down to write.

FIG. 25

6. Draw a decorative border, using any combination of these shapes (Fig. 26). Borders are an important part of this practice. Suggested borders are given at the end of almost every lesson, but feel free to make up your own, using different size nibs and colors. They will give you practice with the fundamental strokes, and can also be used later to decorate finished pieces.

FIG. 26

THE STRAIGHT LINE AND THE CIRCLE

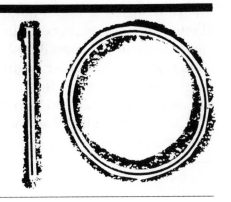

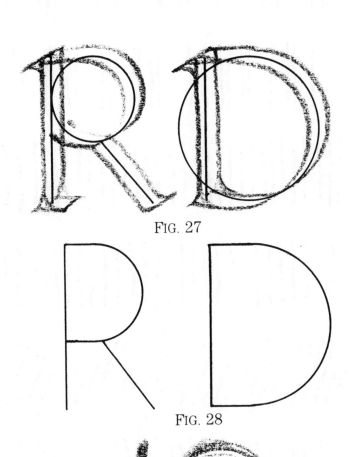

FIG. 27

FIG. 28

FIG. 29

ALL the Roman letters are based on the straight line and the curved lines of the circle (Fig. 27). (The Arabic numerals are derived from a different culture. The basis of their form is not the line and circle, but their shapes have been adapted to correspond to geometric letter forms—the line and the circle.) The Roman letters can be drawn geometrically with a straight-edge ruler and a compass (Fig. 28). But these tools are not appropriate for freehand writing. You do not need a precision instrument to draw the "stick" and the "ball" (Fig. 29).

In the exercises that follow, start with these rough forms. You need not be an artist to execute them, but they will give you a start in forming all the letters. With practice you will gradually be able to refine them into a fairly straight line and round circle.

This lesson is the foundation

for the entire Roman hand. Many exercises have been included—some for special problems that usually bother beginners. You do not need to do all the exercises—just do those that will help you solve your problems.

EXERCISES

1. Start with a series of vertical lines (Fig. 30).
2. Here are some examples of common faults that appear in this exercise:
(a) The lines are slanted both to right and to left (Fig. 31).
(b) The spaces between the lines are not equal (Fig. 32).
(c) The lines are extended above and below the guidelines (Fig. 33).
(d) The lines are broken (Fig. 34).
Look at the vertical lines you draw. If you see any of these faults, use the proper exercise to correct it. Correct one fault at a time. If you can see it, you can do something about it.
3. These are the exercises to correct the faults just described:
(a) Slanting from right to left: Draw lines slanting to the left (Fig. 35).
Draw lines slanting to the right (Fig. 36).

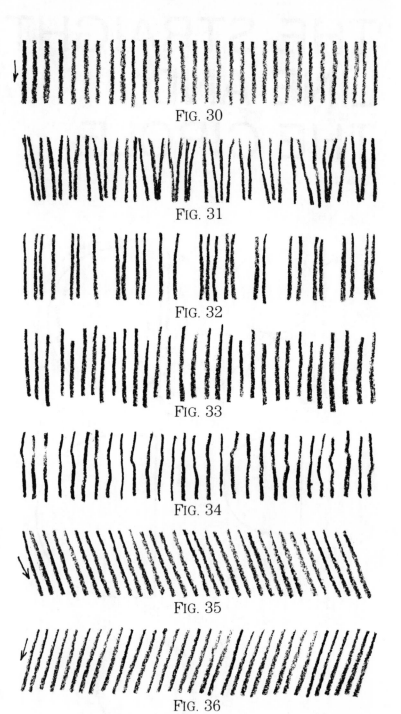

FIG. 30

FIG. 31

FIG. 32

FIG. 33

FIG. 34

FIG. 35

FIG. 36

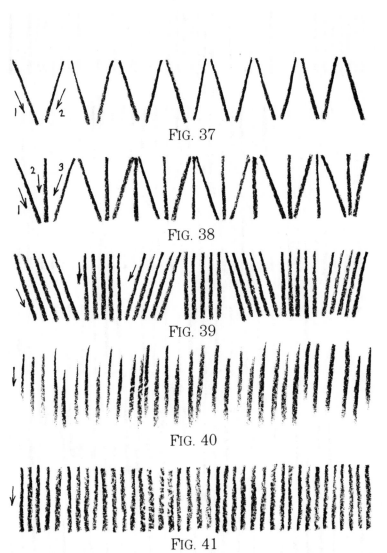

FIG. 37

FIG. 38

FIG. 39

FIG. 40

FIG. 41

FIG. 42

FIG. 43

Draw alternating left and right slants (Fig. 37).

Draw alternating left and right slants with a vertical line between (Fig. 38).

Draw groups of lines slanting left, right, and vertical (Fig. 39).

(b) Unequal spacing:

Draw vertical lines rapidly, without bothering about spacing (Fig. 40).

Draw these lines very slowly and then at a comfortable speed (Fig. 41).

Begin to look at the white space between the lines, not at the lines as you draw them. (They resemble matchsticks in a row with equal space between them.)

Draw lines spaced close together (Fig. 42).

Draw lines spaced far apart (Fig. 43).

Draw groups of lines alternately spaced close together and far apart (Fig. 44).

(c) Lines extended beyond guidelines:

Place the tip of the pencil on the top line and stroke down quickly (Fig. 45).

Place the tip of the pencil at the bottom of the line and stroke up quickly (Fig. 46).

Put dots on the top and bottom guidelines. Start slowly at the top dot and draw down to the bottom dot (Fig. 47). Repeat, increasing your speed but always starting and stopping at the guidelines.

(d) Broken lines:

Draw vertical lines rapidly, without bothering about spacing or staying with the guidelines (Fig. 48). Now draw these lines more slowly. Alternate your speed between fast and slow until you find a speed that allows you to stroke evenly, correcting your spacing and extension beyond guidelines (Fig. 49).

4. Do these same vertical line exercises with a broad-edge pen (Fig. 50). If the faults mentioned in Exercise 2 appear, use the correction procedures outlined in Exercise 3.

5. Proceed to circle exercises: Draw spirals with an easy fluid motion (Fig. 51).

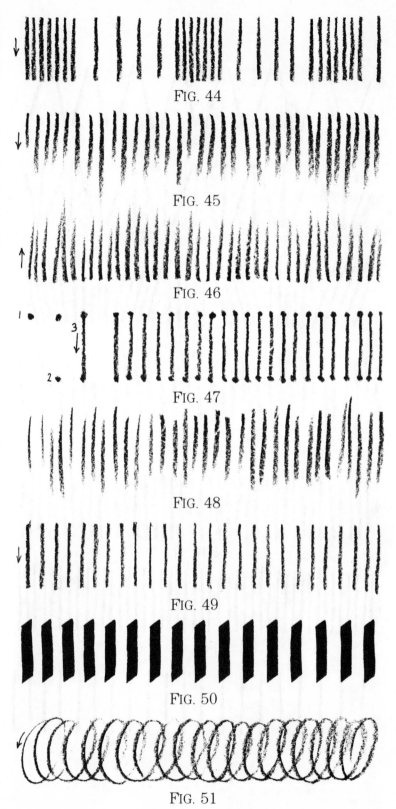

FIG. 44

FIG. 45

FIG. 46

FIG. 47

FIG. 48

FIG. 49

FIG. 50

FIG. 51

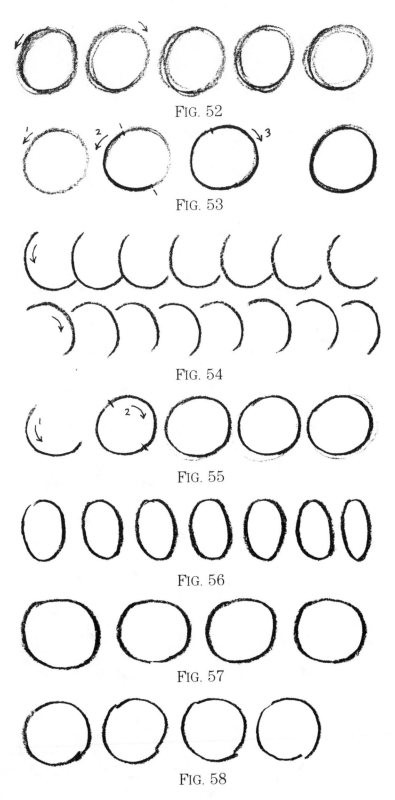

FIG. 52

FIG. 53

FIG. 54

FIG. 55

FIG. 56

FIG. 57

FIG. 58

Draw "balls" (rough circles), both clockwise and counter-clockwise (Fig. 52).

Draw balls, and then wrap half-circles around them, to get the feel of the proper curve (Fig. 53). (Notice that the half-circles are tilted; the reason for this tilt will be explained when you do this exercise with a pen.) Now draw the half-circles alone, without the balls (Fig. 54).

Draw the full circle in two strokes—two half-circles—always starting at the top (Fig. 55).

6. Here are some examples of common faults that appear in the above exercise:

(a) The circles are condensed (vertical ovals) (Fig. 56).

(b) The circles are expanded (horizontal ovals) (Fig. 57).

(c) The lines of the circles do not meet (Fig. 58).

(d) The circles miss the guide-lines (Fig. 59).

(e) The circles are flat on one side (Fig. 60).

(f) The circles are not circles—they are way off the mark (Fig. 61).

Look at the circles you draw. If you see any of these faults, use the proper exercise to correct it.

7. These are the exercises to correct the faults just described.

(a) *Condensed circles:*

(b) *Expanded circles:*

Roughly draw very condensed circles (Fig. 62).

Roughly draw very expanded circles (Fig. 63).

Begin with very condensed circles and draw them less condensed and more expanded until they are very expanded (Fig. 64).

Draw a condensed circle, a real circle, an expanded circle, and then repeat these, in a series (Fig. 65).

(c) *Lines that do not meet:*

Draw large dots at starting and stopping points.

Draw the curves slowly to meet the dots. Then draw the curves slowly without the dots. Gradually increase the speed (Fig. 66).

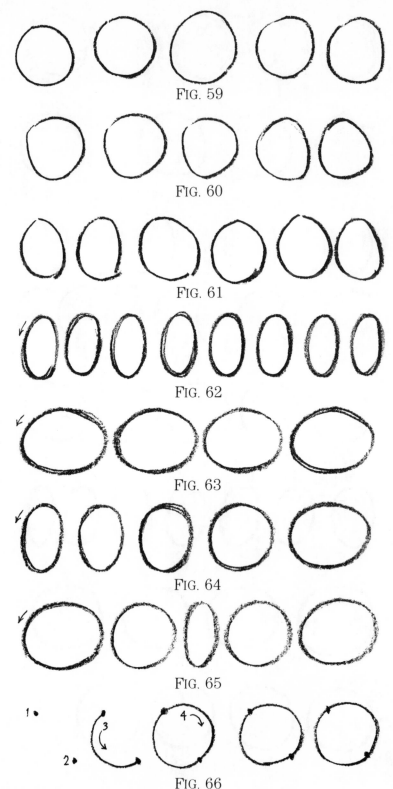

FIG. 59

FIG. 60

FIG. 61

FIG. 62

FIG. 63

FIG. 64

FIG. 65

FIG. 66

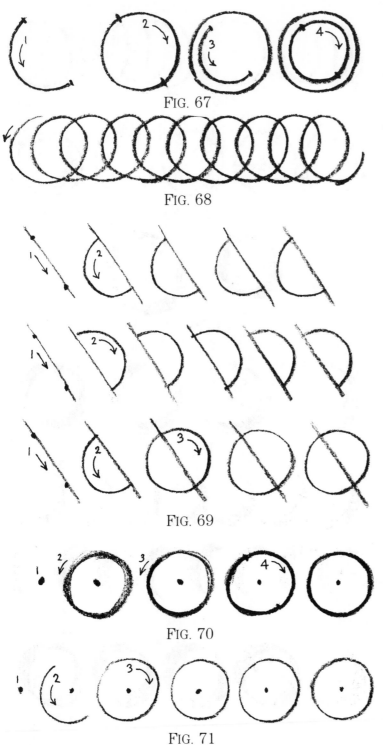

FIG. 67

FIG. 68

FIG. 69

FIG. 70

FIG. 71

(d) *Missing the guidelines:* Draw a circle starting and stopping on the guidelines. Now draw a proper size circle inside the first circle (Fig. 67). Draw a precise continuous spiral. Draw it slowly and be sure to hit the guidelines perfectly (Fig. 68).

(e) *Flat-sided circles:* Draw a diagonal line between starting and stopping points. Add half circles. Then draw circles symmetrically around it (Fig. 69).

(f) *Way-off-the-mark circles:* Make a dot and draw a ball around it, then add a circle (Fig. 70).

Now make a dot and draw a circle around it (Fig. 71).

Draw a loose spiral, a circle with a dot in the middle, and so on (Fig. 72).

Draw circles in one continuous line from different starting points (Fig. 73).

8. Now the circle exercises can be done with the broad-edge pen. Be sure to hold the pen at the same angle you used when drawing the vertical lines—in fact, keep this angle for the rest of the exercises in the Roman section. Start the pen just below the top guideline and finish it just above the bottom guideline. (If the starting and stopping points are right on the guidelines, the circle will go beyond the guidelines.) Notice that the stroke starts thin, becomes thick, and ends thin (Fig. 74).

Begin with balls, and wrap half-circles around them (Fig. 75).

Practice with half-circles without balls (Fig. 76).

Now practice circles without balls (Fig. 77).

Do the same exercises given for pencil circles, using the pen. If you observe faults, correct them as you did in the pencil exercises. Your lines may appear clumsy at first, but as you get used to this new tool (the pen), your shapes will become smoother and more refined. Practice the borders made up of straight and curved lines (Fig. 78).

Keep at it!

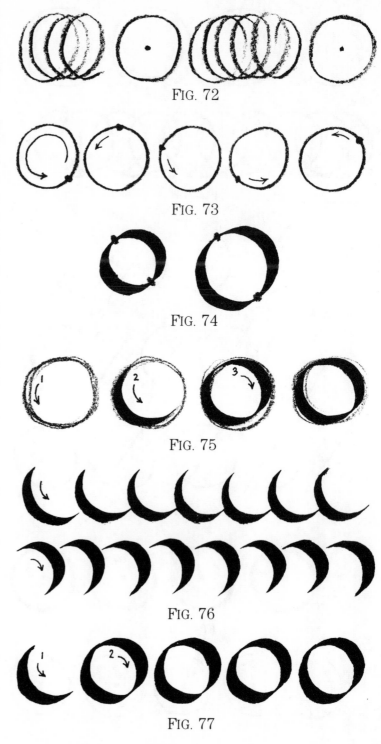

FIG. 72

FIG. 73

FIG. 74

FIG. 75

FIG. 76

FIG. 77

FIG. 78

roman
lower case

VERTICAL

l bdhiklmnpqru

HORIZONTAL

‾ eftz e

DIAGONAL

\ kxij.:; \ vw

/ vw / kxz

CURVE

ꙩ bcdegopq e

ꙩ as

CURVE AND STRAIGHT

ꙵ ahmnr

ι tuy

ɉ gjy

ſ f

FIG. 79

ROMAN LOWER CASE: THE BASIC STROKES

FIG. 80

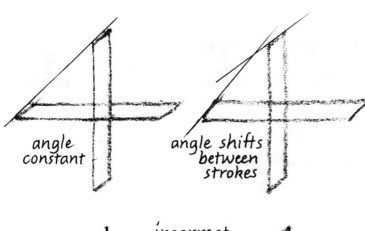

angle constant

angle shifts between strokes

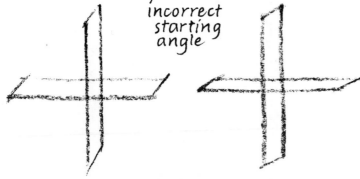

incorrect starting angle

FIG. 81

THE straight line and the curved lines of the circle, used separately or joined together, form the 10 basic strokes. As shown in Figure 79 and demonstrated in this lesson, they can form all the lower-case Roman letters.

To draw these lines correctly, you must first learn to hold the pen at the proper angle. This angle was demonstrated in Lesson 2 as a slight slant. The way to achieve the exact slant is by drawing a series of crosses (Fig. 80) thus: Make a vertical line; then make a horizontal line of the same thickness as the vertical line. If your two lines differ in thickness, you either began with the wrong pen angle or shifted the pen angle between drawing the two lines (Fig. 81). Before you begin work each day, draw these crosses until you can keep a constant angle. It is easier for the beginner to draw all letters with a constant angle. After a fair degree of hand

control is achieved, the angle may be manipulated for special effects.

EXERCISES

Draw a series of vertical lines (Fig. 82).
Draw a series of horizontal lines (Fig. 83).
Draw a series of crosses (Fig. 84). (Avoid the temptation to shift the angle of the pen when shifting from vertical to horizontal.)
Draw the shapes shown in Figure 85.

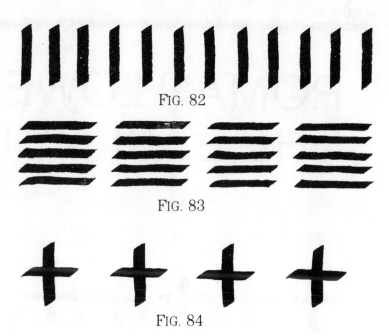

FIG. 82

FIG. 83

FIG. 84

FIG. 85

VERTICALS AND HORIZONTALS

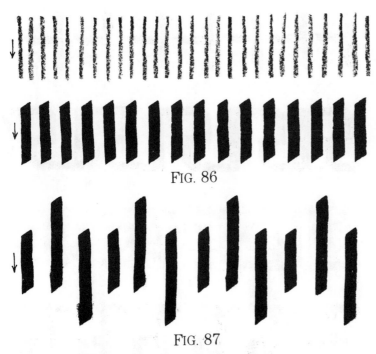

FIG. 86

FIG. 87

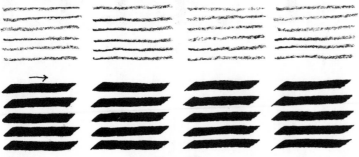

FIG. 88

NEXT to the dot or period (which comes up in the next lesson), the vertical is the easiest stroke to draw. Vertical strokes must stand up straight; they are the posts on which a fence of other letter forms are to be hung. See that the slant at each end of your vertical stroke conforms with the pen angle you learned in the last lesson.

The horizontal is slightly harder to draw, but it doesn't appear in many letters, and it is always quite short. Notice the angle at each end of the horizontal stroke is the same as the angle at the end of the vertical strokes.

The exercises in the book may be copied freehand or they may be traced. Tracing is not cheating. Many calligraphers practice it to get the "feel" of the strokes. You may also get the feel of letters by stroking over the examples in the book with a dry pen, or you may start your exercises by writing with plain water.

EXERCISES

1. Draw vertical lines of the same length with pencil and then with pen (Fig. 86). Pay attention to making the strokes very straight, to keeping the pen angle constant, to equal spacing between lines, and to meeting the guidelines exactly. Practice this attention with all future letters.

2. Draw in succession, with pen, three kinds of vertical lines: within the guidelines; ascending above the top guideline; descending below the lower guideline. Repeat as a series (Fig. 87).

3. Draw horizontal strokes, with pencil and pen, from left to right (Fig. 88). Keep your pen at a constant angle and draw the horizontals at the same thickness as the verticals of Exercise 1.

4. As a further check on your pen angle, draw a cross in ink. Now, draw a diamond in pencil around the ends of the cross. If the ends of the penciled line fit the corners of the diamond, your pen angle was correct (Fig. 89).

5. Draw the shapes shown in Figure 90. This is a good exercise for developing decorative borders.

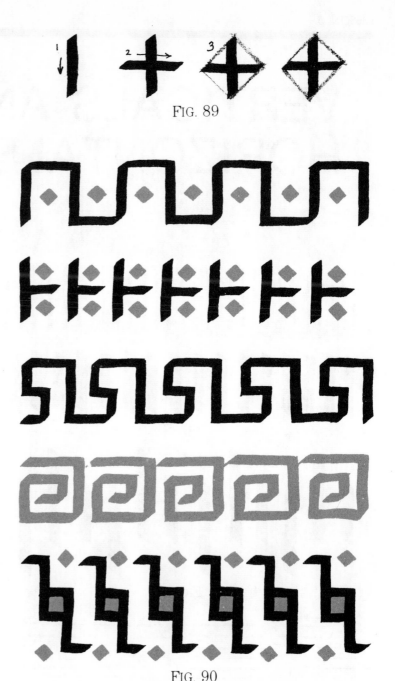

FIG. 89

FIG. 90

DIAGONALS

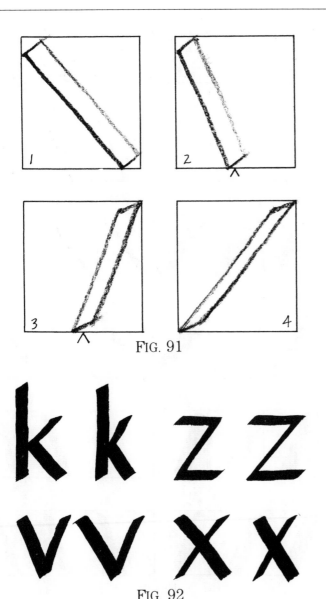

FIG. 91

FIG. 92

BASICALLY, there are two diagonal strokes, the thick stroke and the thin stroke. Each of these is drawn at two different angles which changes their thickness. And there is a very short diagonal stroke—the dot.

To demonstrate the differences in angle and thickness, the four strokes have been drawn within four equal rectangles (Fig. 91). Note that (1) and (4) are drawn from corner to corner while (2) and (3) are drawn from the corners of the top line to the middle of the bottom line. Also notice how the change in angle causes a corresponding change in the thickness of the line.

To aid your practice in drawing the correct angles, boxes have been provided in the Appendix. After sufficient practice, you will begin to see by the thickness of the line coming out of your pen whether or not the angle is correct. In addition, if

you draw the wrong angle, some of the letters will simply not look right (Fig. 92).

If you are working with a nib size that is different from the one used in these exercises, you can still use the boxes to get the proper angles. Just draw the diagonal lines longer or shorter according to your nib size.

EXERCISES

1. Use the guideline sheet in the Appendix, under the ruled paper which lets the rectangles show through. Using the rectangle as a guide, draw diagonals from the top corner to the bottom corner, and then from the upper corner to the middle of the bottom line. Then do it on a line without the rectangle guides. First use pencil and then use pen (Fig. 93).

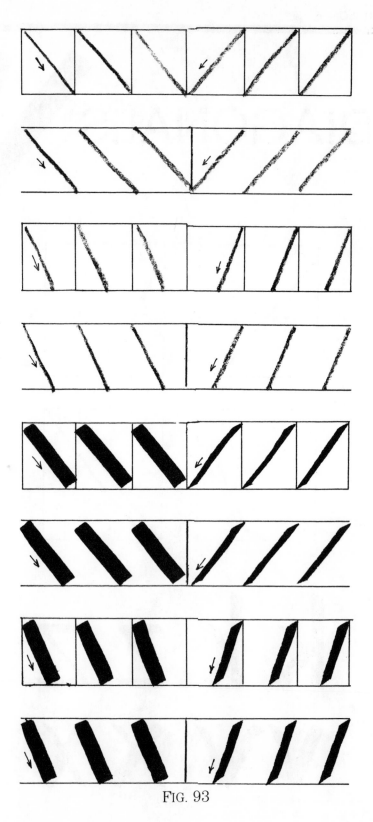

FIG. 93

2. Draw wide and narrow x's with and without the rectangular guides (Fig. 94).

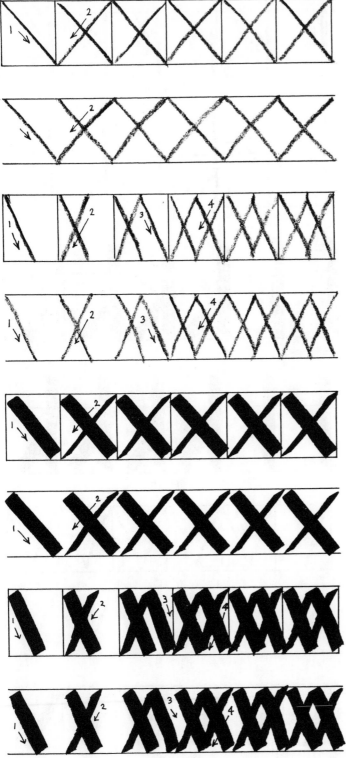

FIG. 94

3. To form the letter *k,* draw a vertical stroke in pencil along the left side of the box starting above the upper guideline. Now draw the diagonals, (Fig. 95) from the middle of the upper guidelines slanting to the middle of the vertical within the box, then down to the middle of the base line. After practicing this, do the same with the pen (Fig. 96). Notice that the left-slanting diagonal stroke is thin, while the right-slanting diagonal stroke is thick.

4. To form the letter *v,* draw a diagonal stroke in pencil from the upper left corner of the box to the middle of the base line, then draw another from the upper right corner to the middle of the base line (Fig. 97). Do the same with the pen. Notice again that the left-slanting diagonal stroke is thin, while the right-slanting stroke is thick (Fig. 98).

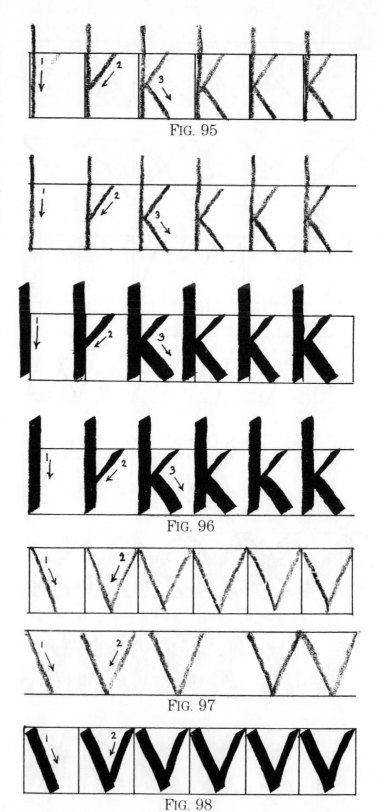

FIG. 95

FIG. 96

FIG. 97

FIG. 98

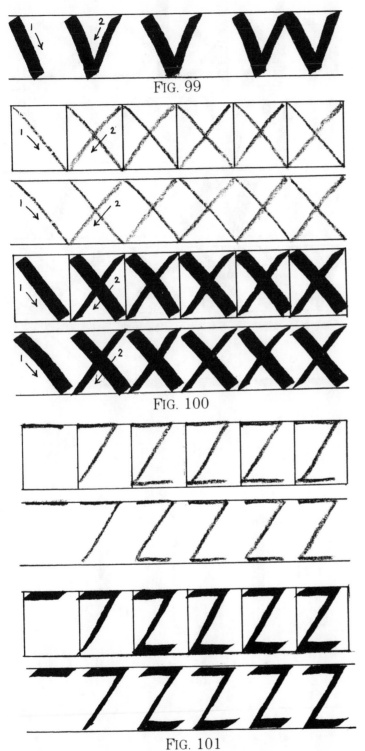

FIG. 99

FIG. 100

FIG. 101

5. To form the letter *w*, merely form a double *v* (Fig. 99).

6. To form the letter *x*, cross two diagonals within a box the size occupied by *v* (Fig. 100). The left-slanting diagonal is thinner than the other.

7. To form the letter *z*, draw a horizontal stroke along the upper guideline, not quite as wide as the previous box. Draw a left-slanting diagonal stroke to the lower left corner of the box, then another horizontal stroke along the base line the same width as the upper horizontal stroke (Fig. 101). Notice that the left-slanting diagonal stroke is not as thick as the horizontal strokes.

8. Draw each of the letters demonstrated in this lesson, in a condensed version (which looks out of proportion), and gradually increase the angles until you have an expanded version (also out of proportion). Repeat this (Fig. 102) until you get a feel for the correct angle.

9. To draw a dot with a pen, make a very short diagonal, with a diamond shape, as long as the width of the pen nib (Fig. 103).

10. With the dot, you can begin a practice that will be helpful in many ways in the practice of positioning strokes properly. Placing the dot too high or too low in relation to the vertical stroke of the *i* makes quite a difference (Fig. 104). As you gain hand control, you will be able to execute your judgment on drawing each stroke in relation to the adjoining strokes and every letter in relation to its neighbors.

Start with these simple exercises. First make pencil dots along a guideline, equally spaced apart (Fig. 105).

Then make pencil dots equally spaced and midway between the guidelines (Fig. 106).

Then make colons (Fig. 107).

11. The vertical stroke and dot form the letter *i* (Fig. 108).

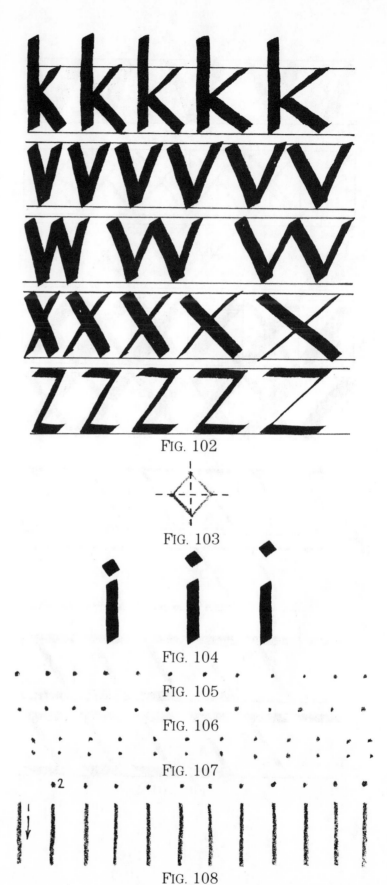

FIG. 102

FIG. 103

FIG. 104

FIG. 105

FIG. 106

FIG. 107

FIG. 108

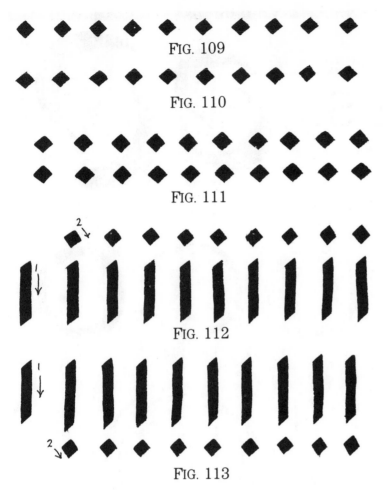

FIG. 109

FIG. 110

FIG. 111

FIG. 112

FIG. 113

12. With a pen, draw dots with side corners resting on the guideline (Fig. 109). Then repeat the other dot exercises (Fig. 110 and Fig. 111) and the letter *i* (Fig. 112).

13. To form an exclamation mark (!), place a dot below a vertical (Fig. 113). The dot rests on the base line and the vertical extends above the guideline.

14. Practice diagonal strokes to make borders (Fig. 114).

FIG. 114

CURVES

YOU have now completed all the strokes formed by straight lines. This lesson begins the strokes formed by curved lines.

The basic curved stroke is a half-circle that begins at the thin and ends at the thin. The complete circle is made up of complementary curves that join at the thins. The only characters that are complete circles are the *o* and the zero. All the rest use segments of these basic curves.

Approach the circle in stages (Fig. 115). First, draw a rough pencil ball as freely as a child draws an orange with a crayon. Wrap two pencil half circles around this ball. Get the feel of these curved strokes around the ball before you draw them without the ball. Draw another pencil ball and wrap two half-circles in ink around it.

Ideally, the pen strokes wrap around the perfect circle (the dotted line in Fig. 116). In practice, form as smooth and

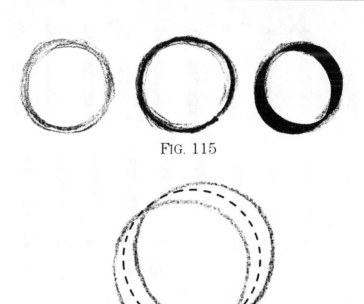

FIG. 115

FIG. 116

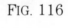
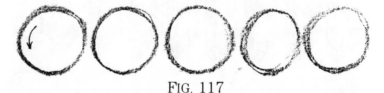

FIG. 117

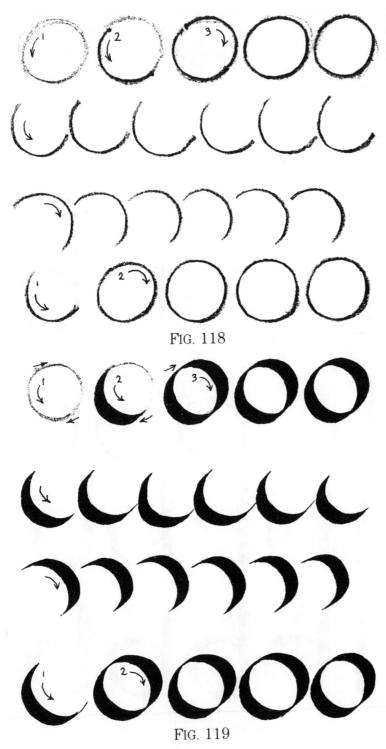

FIG. 118

FIG. 119

symmetrical curves as you can. The final step is to form circles in ink without the ball. Before touching the paper, twirl the pen around an invisible ball over the intended spot.

Note that the circle exercises in pencil and the balls drawn in pencil for the pen exercises are different sizes. The pencil balls are smaller. Their starting and stopping points fall within the guidelines. This allows the pen lines to touch the guidelines properly. Otherwise the pen lines would overlap the guidelines.

EXERCISES

1. With pencil, draw a number of balls counterclockwise (Fig. 117).

Around the ball, wrap half-circles counterclockwise and clockwise. Do these half-circles in single strokes. Then draw half circles and full circles (Fig. 118).

2. Follow the same procedure with pen, wrapping ink curves around pencil balls, half-circles, and then full circles (Fig. 119).

In the *b,* the thin of the clock-wise curve (a) springs from the vertical stroke (Fig. 120). Do not draw a complete counter-clockwise stroke. A complete stroke would extend beyond the vertical (b). Just draw the bottom section (c). The same is true for the *d, f,* and *q.*

3. To form the letter *b* (Fig. 121), draw a vertical ascender (ascending above the guide-line), a clockwise curve spring-ing from the vertical, and a partial counterclockwise stroke.

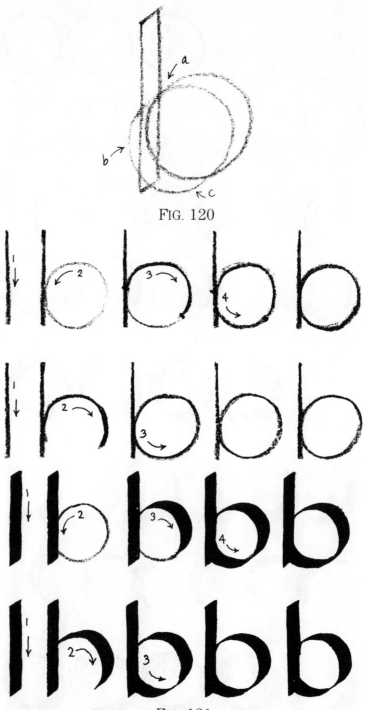

FIG. 120

FIG. 121

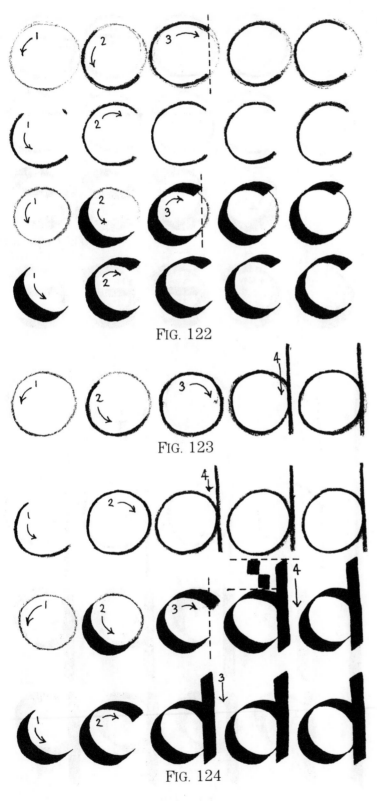

FIG. 122

FIG. 123

FIG. 124

4. To form the letter *c* (Fig. 122), complete the left half-circle, but draw the right (clockwise) half-circle to end directly over the top of the left half-circle stroke.

5. To form the letter *d,* the circle is drawn to the left of a vertical. (This vertical is not as high as the other ascenders; it is only 7 nibs high, while the others are 8 nibs high.) The left half-circle ends with its thin just touching the vertical, while the right half-circle extends into and joins the vertical (Fig. 123). Notice the difference between the pen strokes (1) and (2) of the *d* (Fig. 124) and the *c.*

6. To form the letter *e,* draw a *c.* Then, from the left half-circle, draw a horizontal stroke which is *above* the halfway mark between the guidelines (a) to touch the short right curve (Fig. 125).

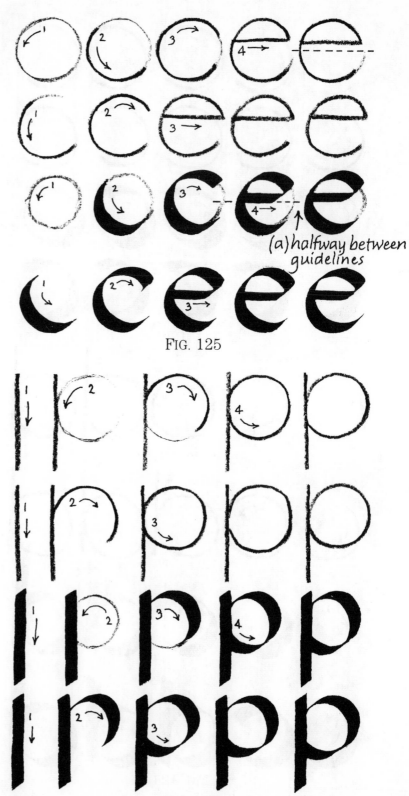

FIG. 125

FIG. 126

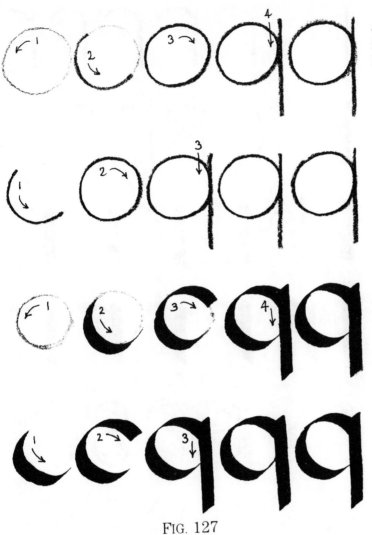

7. Draw the letters *p* (Fig. 126) and *q* (Fig. 127), which are similar to the letters *b* and *d*, except the verticals are descenders.

FIG. 127

8. To form the letter *r*, draw a vertical stroke within the guidelines. Then begin the right half-circle but stop just as it is at its maximum thickness. Notice that the ball around which the half-circle is wrapped is smaller than that used in the previous letters (Fig. 128).

9. To form the letter *s*, even smaller balls are used; they line up, one above the other within the guidelines, but at a slight leftward slant to compensate for the width of the nib (Fig. 129).

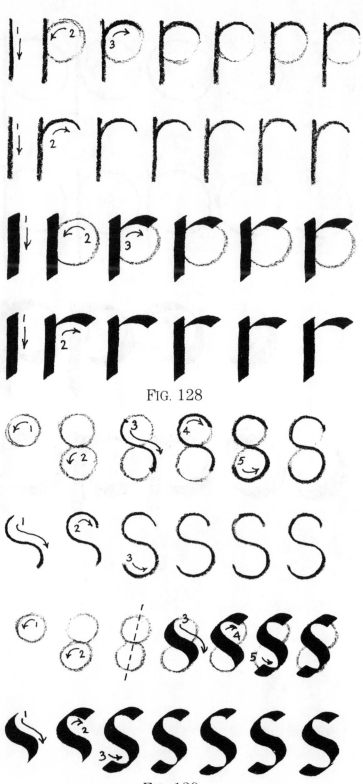

FIG. 128

FIG. 129

10. Practice the use of curves by making the borders and words in Figure 130.

wow
beep
sizzle
cove
ox skill
pride

FIG. 130

STRAIGHT AND CURVE

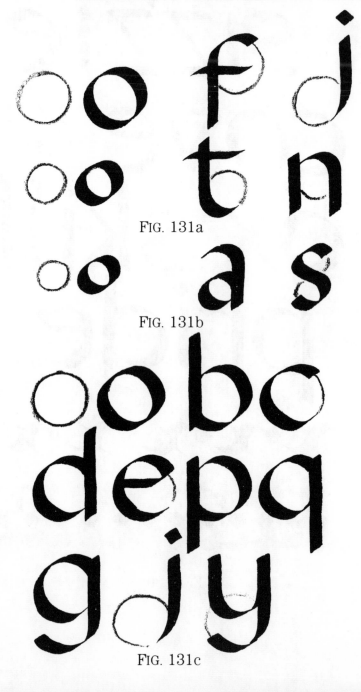

T HE four strokes in this lesson are combinations of straight and curved strokes. The curves go around balls of two sizes: full size, and three-fourths size (Fig. 131a). A half-size ball is used with the curved strokes in the letters *a* and *s* (Fig. 131b).

(1) *FULL SIZE.* This is the size of the letter *o.* Most of the circles used in Lesson 7 *b, c, d, e, p* and *q* were this size. In this lesson, the descenders from *g, j* and *y* join curves of this size (Fig. 131c).

FIG. 131a

FIG. 131b

FIG. 131c

 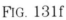

FIG. 131d

FIG. 131e

FIG. 131f

Pencil

Pen

(2) *THREE-FOURTHS SIZE.* In Lesson 7, the letter *r* used this size. It is used in this lesson by most of the letters: *a, f, h, m, n, t, u,* and *y* (Fig. 131d).

(3) *HALF SIZE.* This is used only in the letter *s* (shown in Lesson 7) and the letter *a* (in this lesson) (Fig. 131e).

In the following exercises, notice that the pen balls are smaller than the pencil balls. This allows the pen strokes, when drawn around the pen balls, to hit the guidelines exactly (Fig. 131f).

EXERCISES

1. Full-Size Balls: The first stroke begins with a descender that extends below the guide-line, curves to the left, and ends in the thin. It is joined by a curve from the left. Later on, you will be able to make this stroke in one motion (Fig. 132).

The letter *j* uses the first half of this stroke which ends in the thin. First draw the full-size ball and then draw the descender down into and around the curve. Make the dot over the *j* as precise as the dot over the *i* (Fig. 133).

The letter *g* uses two full-size balls. It begins like the *d* and then the descender and bottom curve are added (Fig. 134).

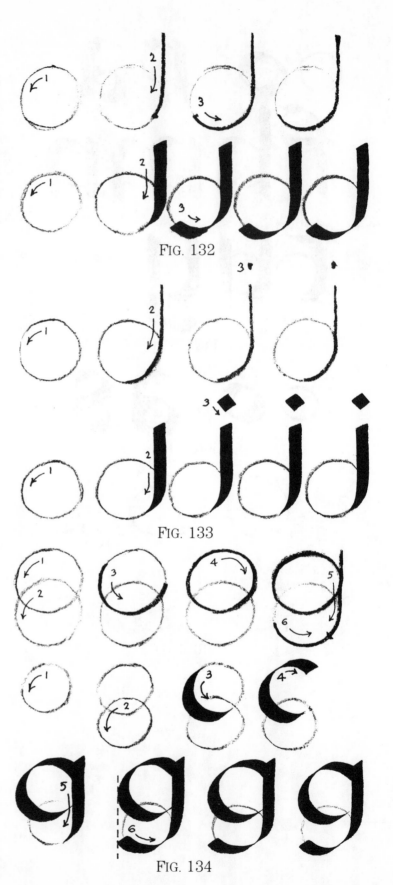

FIG. 132

FIG. 133

FIG. 134

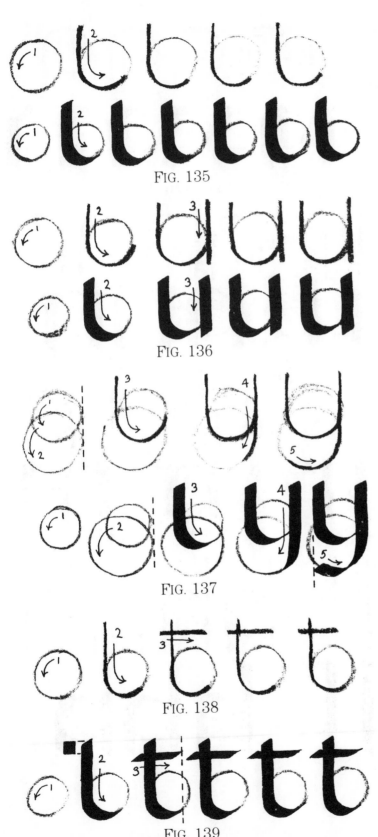

FIG. 135

FIG. 136

FIG. 137

FIG. 138

FIG. 139

2. Three-Quarter Size Balls: The second stroke begins with a vertical within the guidelines, joins the ball to the right and ends in the thin (Fig. 135).

The letter *u* begins with this stroke and adds another vertical (Fig. 136).

The letter *y* uses a three-quarter ball on top and a full size ball on the bottom. Notice the way they are lined up evenly on the right (indicated by the dotted line). It starts out like the *u* and then adds the curved descender (Fig. 137).

The letter *t* (Fig. 138) starts this stroke one nib-width above the guideline. Notice that the horizontal crossbar runs underneath the guideline and extends as far to the right as the bottom curve (as indicated by the dotted line) (Fig. 139).

The third stroke is stroke two upside down. It starts from the thin, curves around the ball, and comes down in the vertical (Fig. 140).

The letter *n* starts with a vertical stroke. Springing from the vertical with the thin, draw the curve down into another vertical (Fig. 141).

The letter *m* starts as the *n* and adds another curve and down stroke (Fig. 142).

The letter *h* starts with a vertical ascender and adds a curve and downstroke (Fig. 143).

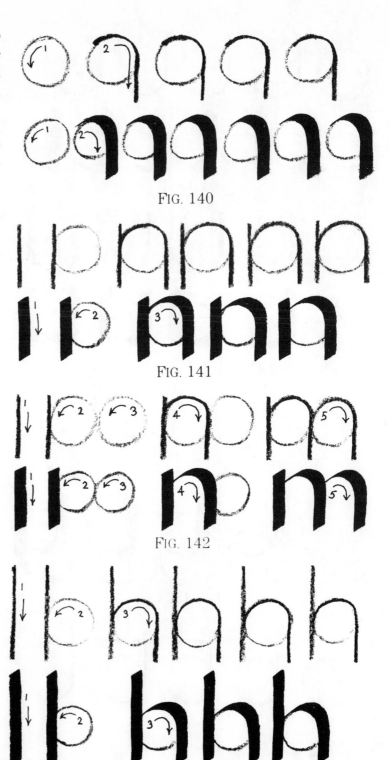

FIG. 140

FIG. 141

FIG. 142

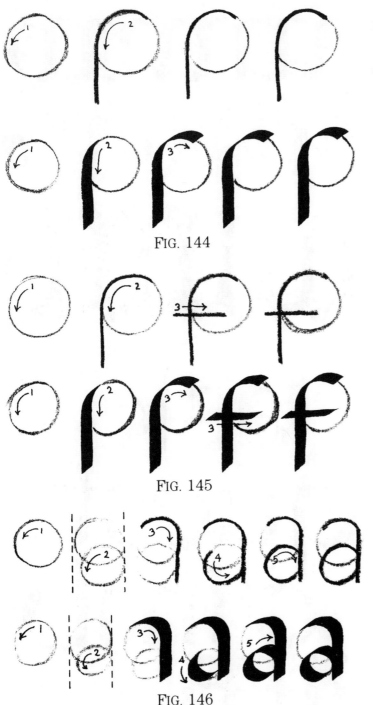

FIG. 144

FIG. 145

FIG. 146

The fourth stroke is like stroke one upside down. It is only used in the letter *f,* and the ball is drawn above the guidelines. Beginning in the thin, it curves around the ball and down into the vertical (Fig. 144).

The letter *f* begins with this stroke and adds a crossbar which, like the crossbar of the *t,* runs underneath the guideline (Fig. 145).

3. Half-Size Ball: The *a* uses a three-quarter ball on top of a half size ball. Notice how they line up on the right side (indicated by the dotted line). First draw the pencil balls. The first pen stroke is the same one used for the *n, m* and *h.* Then a small circle is added at the bottom (Fig. 146). The letter *s* also uses half-size balls.

Now return to the letters learned in Lesson 7 and draw them using the three sizes of ball you have learned in this lesson. 4. Practice the various borders that can be made with these new strokes (Fig. 147). Some words have been suggested, but you can write out any word you want now. With this lesson, you have covered every lower-case letter from *a* to *z*!

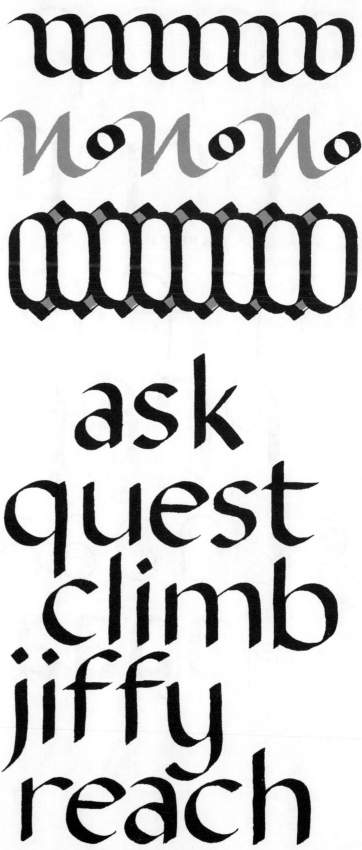

FIG. 147

HOOKS

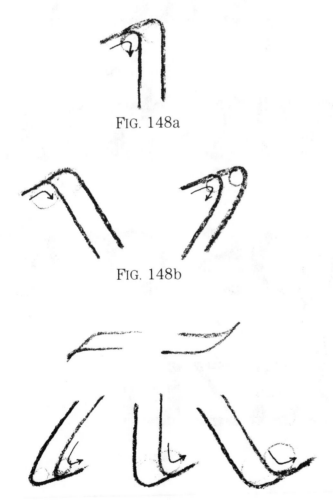

FIG. 148a

FIG. 148b

FIG. 148c

N OW that you have learned the basic letter structures, add finishing touches to them: hooks. These are not full-fledged strokes, but stroke endings. Hooks are used to start letters and end them. The starter hooks begin with a thin line, curve around a tiny ball, and go down into the main stroke (Fig. 148a). The ball is so small that it is not necessary to draw it in pencil as in previous lessons. Hooks added to diagonals are similar (Fig. 148b) but are adjusted to the angle of the main stroke. Small hooks may be added to the horizontal strokes on the *t*, *f*, and the *z*. Hooks that end strokes swing up around the small ball and end in a thin line (Fig. 148c).

Compare the difference in the appearance of "The quick brown fox..." in this lesson (with hooks) and the one in Lesson 1 (without hooks). See how the hooks tie the words together into units.

EXERCISES

Study "The quick brown fox" (Fig. 149) to see how hooks are added to the lower-case letters. Write out the alphabet adding on the hooks.

The quick brown fox jumps over the lazy dog.

FIG. 149

ROMAN
CAPITALS

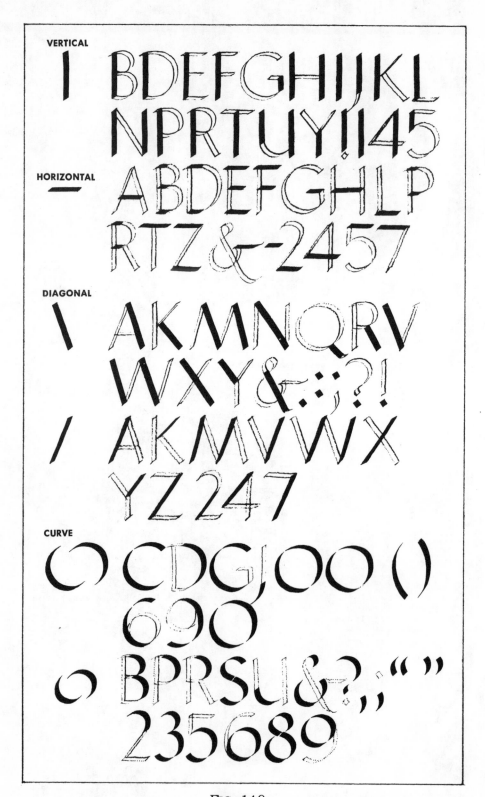

FIG. 149a

ROMAN CAPITALS: THE BASIC STROKES

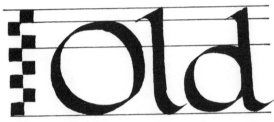

FIG. 150

FIG. 151

![Measure](Measure Measu Mea)

FIG. 152

THE Roman capitals will be easier to learn than the lower-case strokes. They are formed with basic strokes (Fig. 149a) that you have already practiced in the preceeding lessons.

In Figure 150, the word *Old* is written in guidelines according to traditional proportions. The square dots to the left are nib-widths. As illustrated in Lesson 2, the lower-case x-height is five nib-widths high and the ascenders are eight nib-widths high. Capital letters are traditionally seven nib-widths high.

In Figure 151, the word *Old* is written in guidelines taken from the wide-rule blue-line pad we have been using. Notice that the line above the x-height is 7 1/2 nib-widths high. In using the guidelines on this pad, it is convenient to draw both capitals and ascenders to this line (and it does not change the look of the letters very much).

As you develop visual discrimination, you may want to make

changes in size and experiment with different proportions. Finally, you will have to set your own standards for well-proportioned letters. In Figure 152, the word *Measure* is written in a squat fashion, the first five letters in a regular fashion, and the first three letters in an elongated fashion. Which one do you like the best?

EXERCISES

Write out the lower-case letters with x-heights of 2 1/2 and 7 1/2 nib-widths (Fig. 153). This exercise will prepare you for forming the extended lines and enlarged curves of the capitals in the exercises in the following lessons.

FIG. 153

VERTICALS AND HORIZONTALS

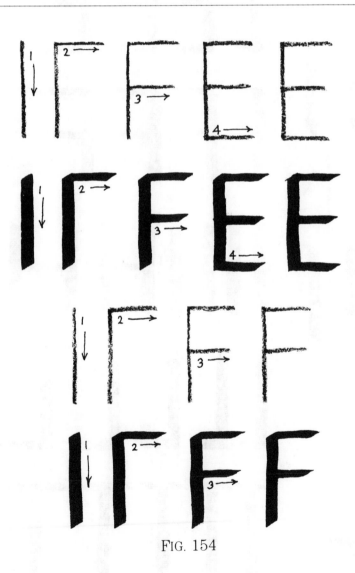

FIG. 154

VERTICAL and horizontal strokes are used to form the Roman capital letters *E, F, H, I, L,* and *T.* There is a short horizontal stroke in *B, D, P* and *R,* which will be discussed in Lesson 13. Since Lesson 5 have your vertical strokes improved?

EXERCISES

1. Practice the formation of vertical and horizontal strokes in the *E, F, H, I, L,* and *T* (Fig. 154).

2. Form letters from an extremely condensed to an expanded form (Fig. 155). Step up the sizes as gradually as possible. This will help you discover the proper width for yourself.

FIG. 154 *(continued)*

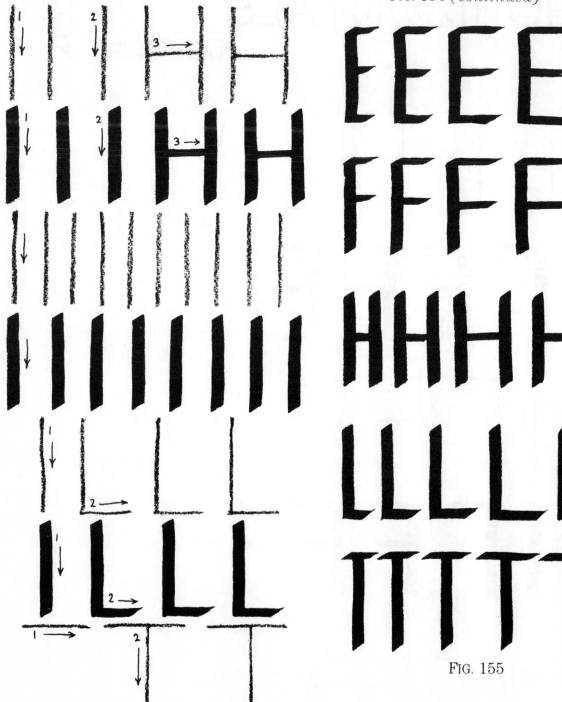

FIG. 154 *(continued)*

FIG. 155

3. Practice borders and words that have vertical and horizontal strokes (Fig. 156).

THE LIFT

FIG. 156

DIAGONALS

MOST of the letters which use diagonals are symmetrical. The symmetry can be seen *in the white space between the diagonal strokes* when a vertical axis is drawn (Fig. 156a). This touches on two important aspects of lettering: the inner space, and the axis. More will be said about the inner space later but these exercises will at least make you aware of it. If all the letters did not stand up along the same axis, they would be flopping around like a field of wheat. In the Appendix, there are provided pages, with axis lines that have been drawn to help you align your letters consistently. By drawing your own axis lines in pencil, you should begin to see when a letter is standing up at the correct angle.

In the following illustrations, to help you see both axis and inner symmetry, vertical lines are first drawn in pencil. In Figure 157 strokes are extended out in equal angles from the vertical pencil lines.

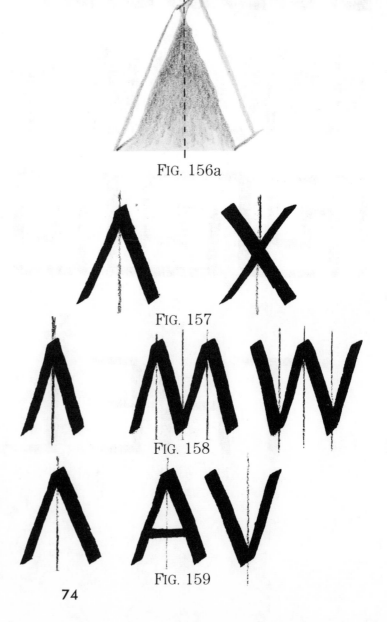

FIG. 156a

FIG. 157

FIG. 158

FIG. 159

The diagonals slant at three different angles: narrow (Fig. 158), medium (Fig. 159), and wide (Fig. 160). Rectangles have not been provided to help you arrive at the proper angle. Instead, use the pencil axis and your awareness of the inner space.

EXERCISES

1. Observe the order of the pencil strokes to form narrow, medium and wide angles on each side of the axis (Fig. 161).

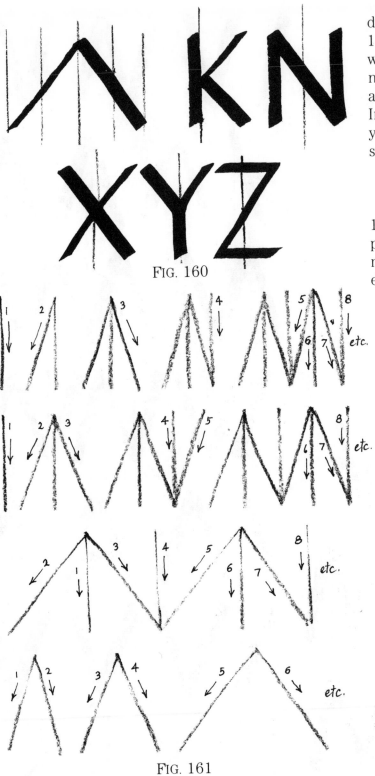

FIG. 160

FIG. 161

2. When diagonal strokes are made with twin pencils, (or with a broad-edge pen), notice that the axis makes equal angles only on the inside space (Fig. 162). This principle must be observed in the following exercises with a pen.

3. Observe and practice the order of pen strokes to form narrow, medium, and wide angles on each side of an axis (Fig. 163).

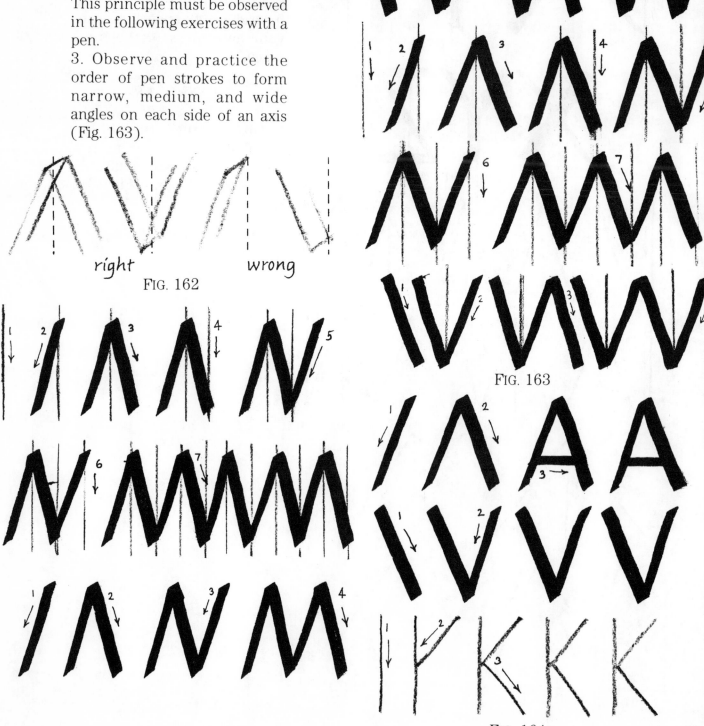

FIG. 162

FIG. 163

FIG. 164

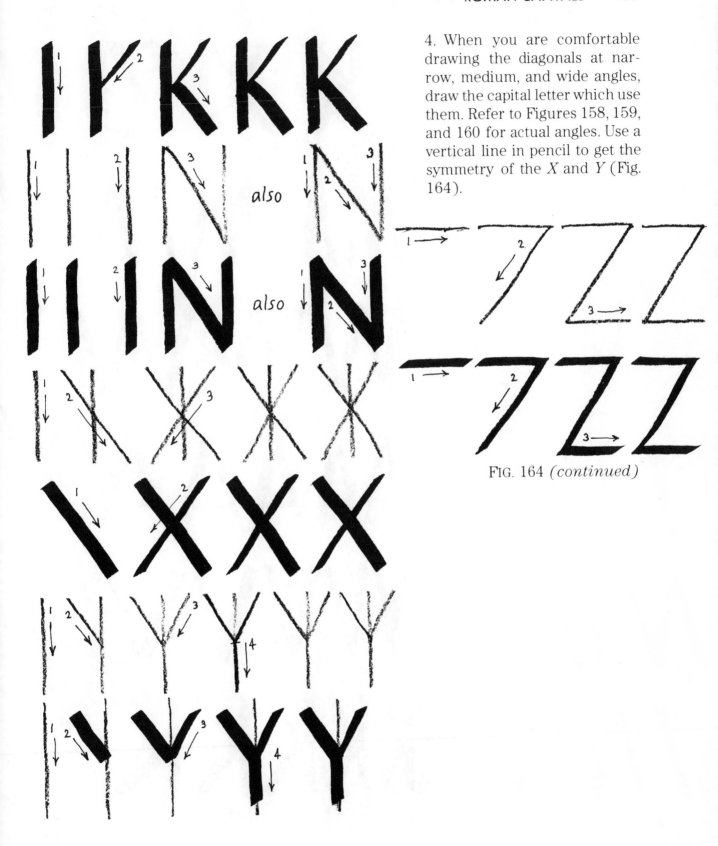

4. When you are comfortable drawing the diagonals at narrow, medium, and wide angles, draw the capital letter which use them. Refer to Figures 158, 159, and 160 for actual angles. Use a vertical line in pencil to get the symmetry of the X and Y (Fig. 164).

FIG. 164 *(continued)*

5. Be sure to line up the top and bottom strokes (Fig. 165).

6. Draw the same letters from a condensed to a more expanded form (Fig. 166).

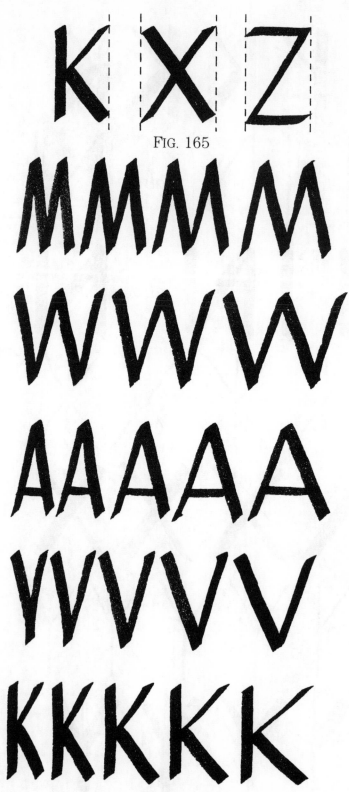

FIG. 165

FIG. 166

NNNN

XXXX

YYYYY

ZZZZZ

FIG. 166 (continued)

7. Practice borders and words which use the diagonal strokes (Fig. 167).

FIX
AIM
WHIZ NAVY
MAKE

FIG. 167

CURVES

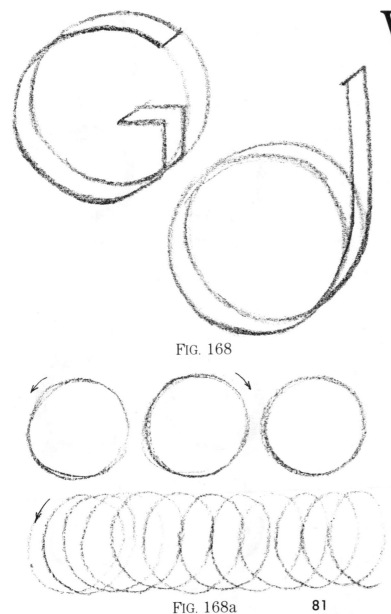

FIG. 168

FIG. 168a

WITH the addition of the curved strokes presented in this lesson, the entire Roman hand—all the capital letters, numerals, and punctuation marks—is complete. The curves of the letters *C, D, G, J, O,* and *Q* are based on the full-size *O* circles. The capital *G* and the capital *J* are based on the full-size *O* in combination with other strokes (Fig. 168). The capital *D* is based on the full-size capital *O* combined with a vertical stroke joined by short horizontal strokes. The curves of the letters *B, P,* and *R* are based on half-size *O*'s. As with the *D*, short horizontals join the vertical strokes to the curved strokes. The letter *S*, the question mark, and the numerals *2, 3,* and *8* are also based on half-size *O*'s. The ampersand, the letter *U*, and the numerals *5* and *6* use a circle three-quarters the size of the *O*. The numerals *6* and *9* combine the three-quarters size *O* with the full circle.

EXERCISES

1. Warm up with full-size circles, drawn clockwise, counterclockwise, and spirals (Fig. 168a).

2. Practice the strokes that are based on the full-size *O* (Figs. 169 and 170).

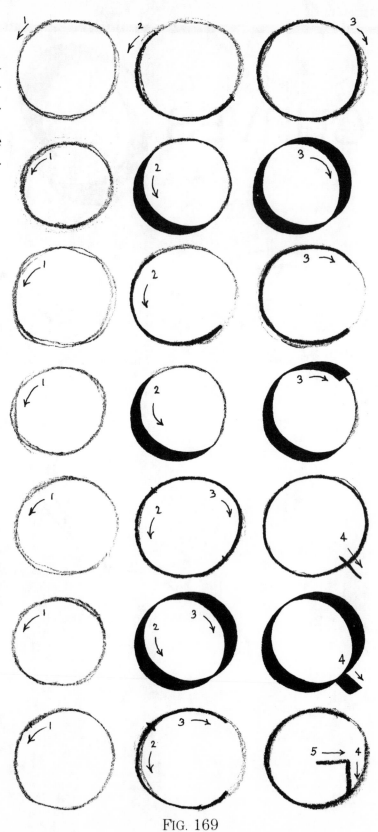

FIG. 169

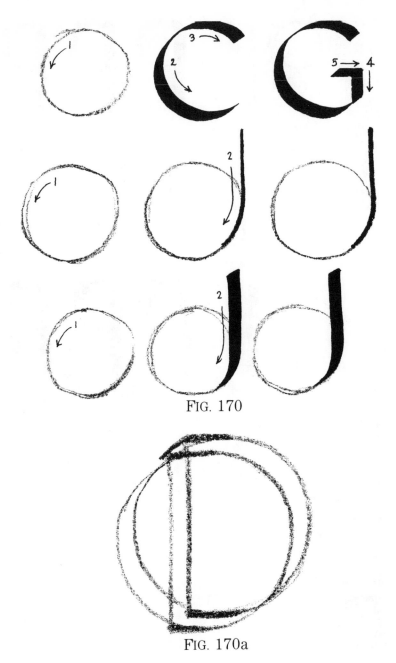

3. In the letter *D*, short horizontal strokes join the curved strokes to the vertical stroke (Fig. 170a). First draw the vertical. Start the right hand curve with a short horizontal, and start the bottom curve with another short horizontal.

Practice the strokes that form the letter *D* and start the bottom curve with another short horizontal (Fig. 171).

FIG. 170

FIG. 170a

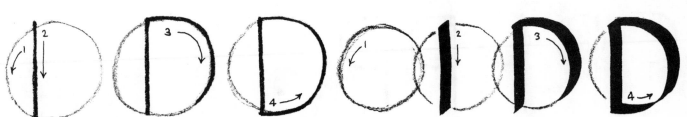

FIG. 171

The letters *B, P,* and *R* also have short horizontal strokes joining the curves to the vertical (Fig. 172).

4. Practice the strokes that form the letters *B, P,* and *R* (Fig. 172a).

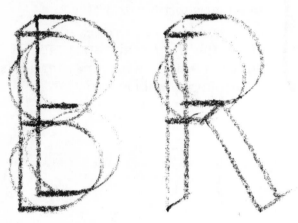

FIG. 172

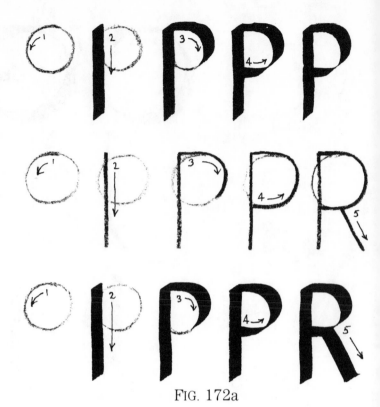

FIG. 172a

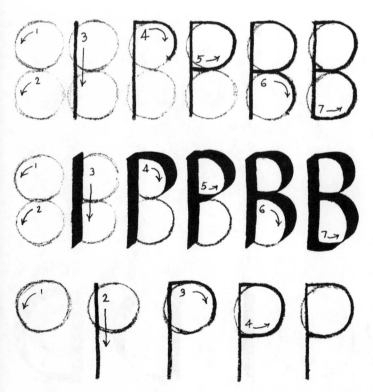

5. Practice the characters, *S, ?, 2, 3* and *8,* that are based on half-size *O*'s (Fig. 173).

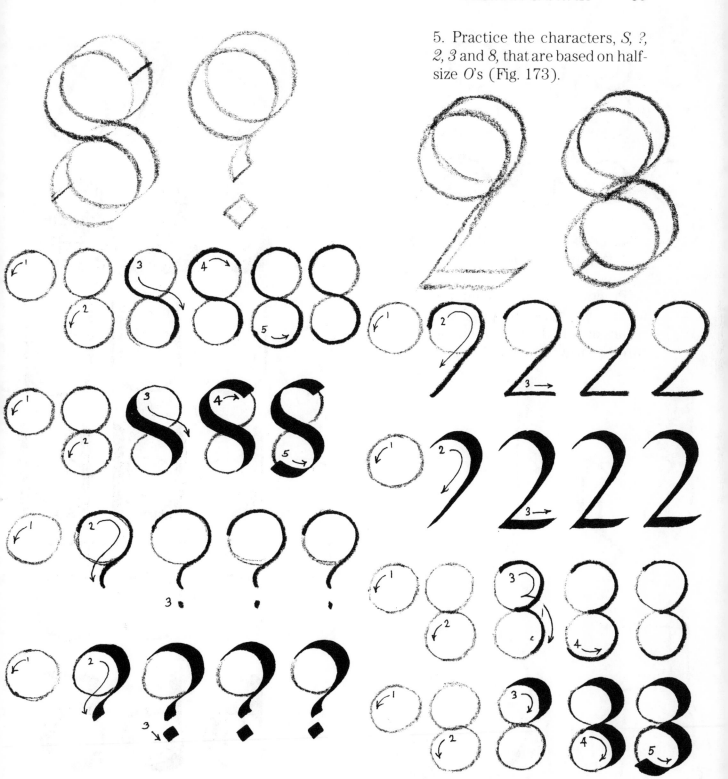

Fig. 173

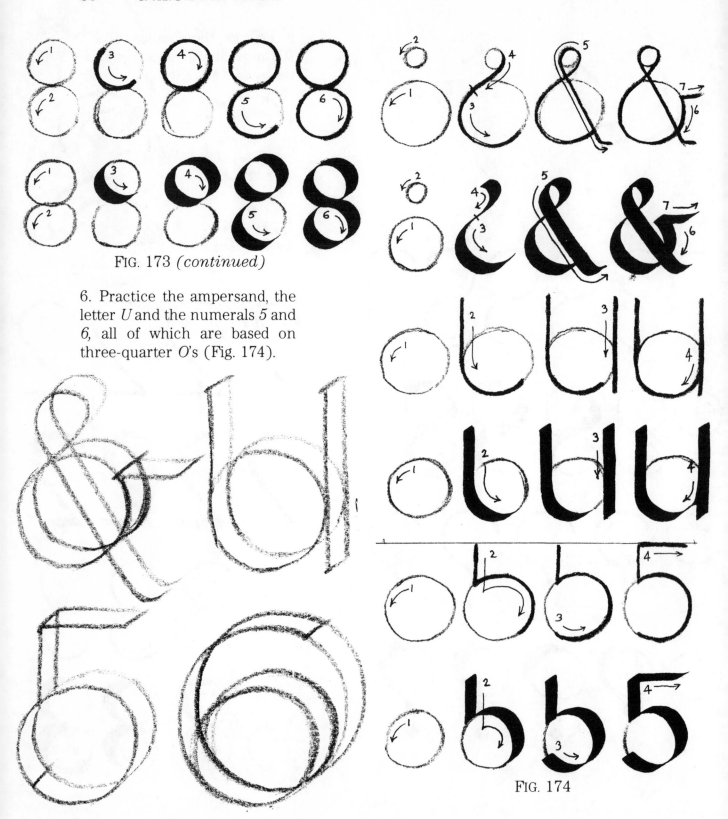

FIG. 173 *(continued)*

6. Practice the ampersand, the letter *U* and the numerals *5* and *6*, all of which are based on three-quarter *O*'s (Fig. 174).

FIG. 174

7. Practice the numerals *6* and *9* that combine the three-quarter circle with the full circle (Fig. 175).

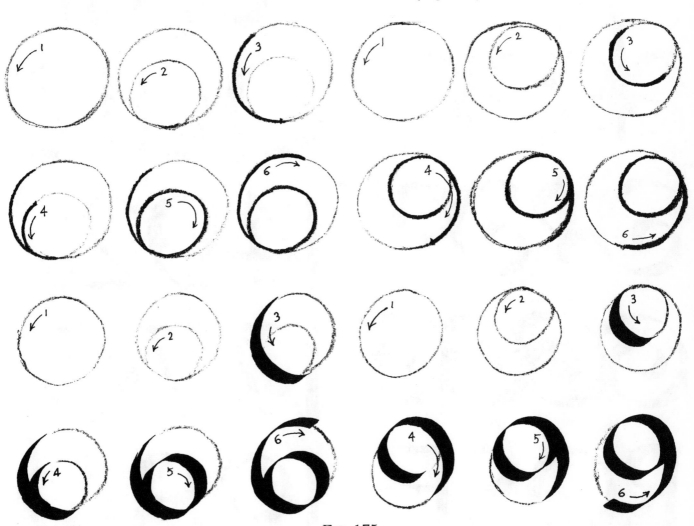

FIG. 175

8. Practice borders and words that use a variety of Roman capital letters and numerals (Fig. 176).

JUMP

QUIZ

1492

1776

1984

ROSE

DUCK

2001

FIG. 176

HOOKS AND PROJECTS

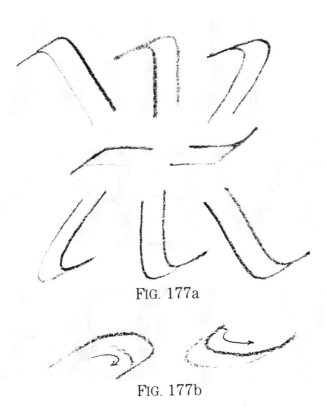

FIG. 177a

FIG. 177b

Now that you have mastered the Roman hand, try it out in a couple of projects. But before you proceed to the projects, observe that capitals get hooks the same as lower-case letters (Fig. 177a). These hooks are formed as shown previously in Lesson 9. However, hooks are also added to the curved strokes of the *C, G,* and *S* (Fig. 177b).

You may notice several unusual elements in this version of "THE QUICK BROWN FOX" (Fig. 177c). The words "QUICK" and "JUMPS" are not separated according to the rule of word division. "The" is written in a small lower case, and the letters of "DOG" are looped together. These things were done so all the letters of the alphabet could fit on the page without reducing their size. When you copy this page, you need not follow this layout.

THE QUIC
K BROWN
FOX JUM
PS OVER the
LAZY DOG.

FIG. 177c

What is a weed? A
plant whose virtues
have not yet been
discovered.

EMERSON

FIG. 178

Project: A Quotation

A popular use of calligraphy is the transcription of favorite quotations, poems, prayers, and the like. These can be highly decorative and make splendid gifts. One of the practice borders can be used in a complementary color around the text, which is usually in small letters except for the initial capital. Roman capitals are appropriate for the author's name (Fig. 178).

Project: A Bookplate

This may be a more difficult project than a quotation, because it must be small enough to fit within a book's page. This will require the use of a pen smaller than the one used for practice. The decorative border will need some figuring, especially at the corners. After you ink in one bookplate, it can be reproduced on a copying machine (Fig. 179). You may want to leave the name and part of the border design blank, and fill them in individually with colored ink. The thin lines in the corners, called crop marks, are for cutting the bookplate to size. Lay a metal-edged rule across them and cut with a single-edge razor blade.

FIG. 179

*italic
lower
case*

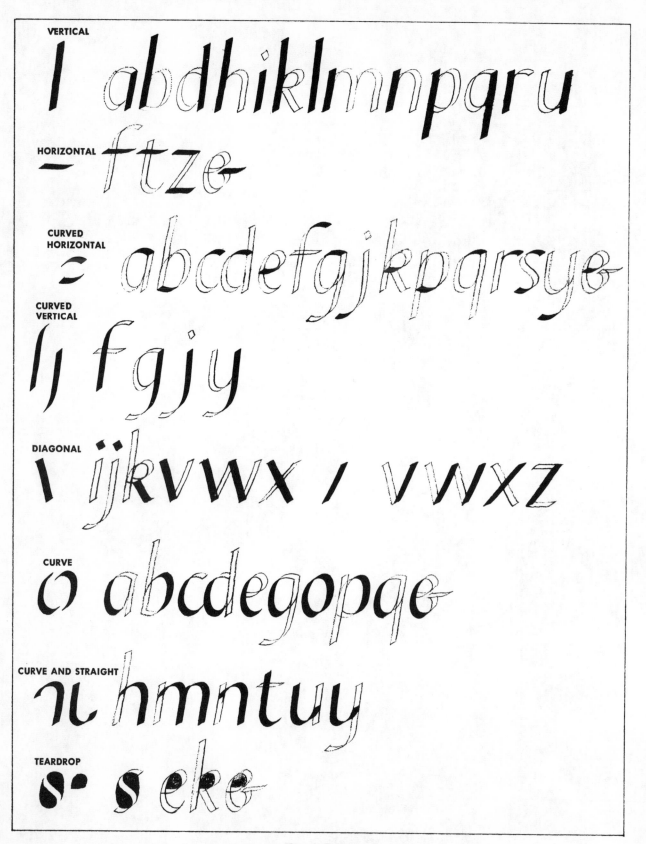

FIG. 179a

ITALIC LOWER CASE: THE BASIC STROKES

January, April, and September. The same lecture is given Monday through Friday (7 - 9:15 p.m. approximately), so that you may vary your evening of attendance from week to week. Join now by mail or from 6:15 p.m. the evening of your first attendance $60.

The 1981 term begins September 14-18.

_____uary 4 - 8,
_____-24.

_____N.Y. 10021

_____ucational organization,
_____rsity of the State of New York.

To be a philosopher
is not merely
to have subtle thoughts,
nor even to found a school,
but so to love wisdom
as to live according to its dictates,
a life of simplicity, independence,
magnanimity, and trust.
It is to solve
some of the problems of life,
not only theoretically,
but practically.

THOREAU

FIG. 180

IN modern type, Italic is used instead of Roman for a variety of reasons—for example, to indicate emphasis, to attract the eye to key words in the text or in subheads, or (by convention) to indicate words in a foreign language, and for titles of books. The basic strokes are demonstrated in Figure 179a.

When the Italic hand was first devised during the Renaissance its function was quite different. As the cursive form of the Roman hand, it was used mainly to enable scribes to write manuscripts in less time and expense—an important consideration in an age when precious parchment, made from sheepskin, was the essential material used for the pages of books and documents. Expenses were reduced because the strokes of Italic flow into each other more freely than the strokes of Roman, saving the time of the scribes; and because the letters are more condensed, more

words could fit on a page. Italic was the informal hand, Roman was the formal hand and was used mainly for official documents. Today, Italic calligraphy is used for its ornamental appearance (Fig. 180) and Roman is used for legibility.

Italic letters differ from Roman letters in two basic ways: the Italic letters slant upward to the right; and they are more condensed (Fig. 181). The Roman straight line becomes the Italic slanted line. (Although it is therefore not a true vertical, we shall continue to call it a vertical to distinguish it from the more slanted diagonal.) The Italic oval is made of two kinds of curve: a flat, wide curve and a sharp, narrow curve (Fig. 182). We shall refer to them simply as wide and narrow curves in the following lessons.

Therefore, the two basic elements of the Roman hand, the straight line and the circle, are changed in the Italic hand to the (slanted) straight line and the (slanted) oval.

The right-upward slant, the axis, has the same angle in all Italic letters. If your present handwriting slants to the right, you can write Italic letters at that angle; in any case, you can use the Italic axis sheet in the appendix.

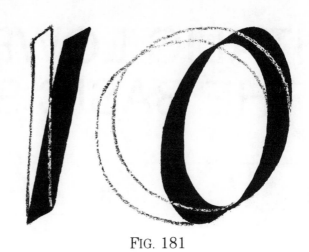

FIG. 181

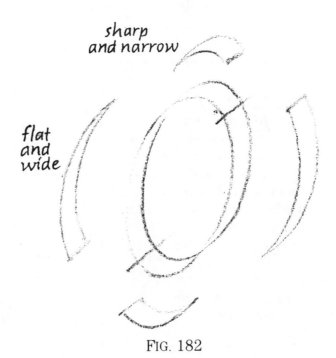

FIG. 182

FIG. 183

FIG. 184

FIG. 185

FIG. 186

FIG. 187

FIG. 188

FIG. 189

FIG. 190

EXERCISES

1. Practice "vertical" strokes (straight lines at the upward-right angle), one row stroking down, another row stroking up (Fig. 183).

2. Combine the slanted Italic vertical with a true vertical to see how they differ (Fig. 184).

3. Try forming the Italic oval in continuous strokes several times around (Fig. 185).

4. Using the guidelines in the appendix, draw axis lines in pencil and form ovals at the correct angle (Fig. 186).

5. Now begin with an inner axis and form an oval around that line (Fig. 187).

6. First draw a rough oval. Then, in two bold strokes, wrap the oval curves around it (Fig. 188).

7. Practice these oval strokes individually (Figs. 189 and 190).

8. Using the two oval curves without the rough oval underneath, form the true oval (Fig. 191).

9. Join the slanted line with curves in one continuous line (Figs. 192 and 193).

10. Practice the slanted line with a pen (Fig. 194).

11. First draw a rough oval in pencil and then wrap the oval strokes around it in ink (Fig. 195).

12. Practice the oval strokes individually (Figs. 196 and 197).

13. Draw the axis in pencil and wrap the oval strokes around it (Fig. 198).

14. Draw the oval without any crutches (Fig. 199).

15. Draw the slanted lines connected with curves in ink (Figs, 200 and 201).

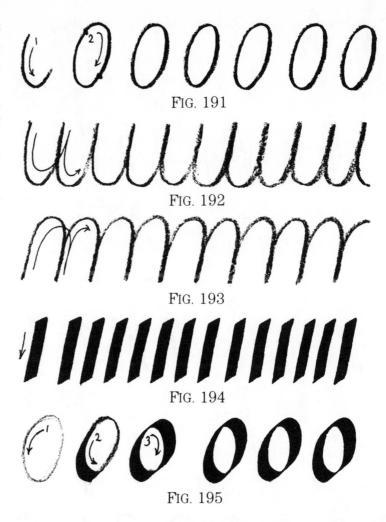

FIG. 191

FIG. 192

FIG. 193

FIG. 194

FIG. 195

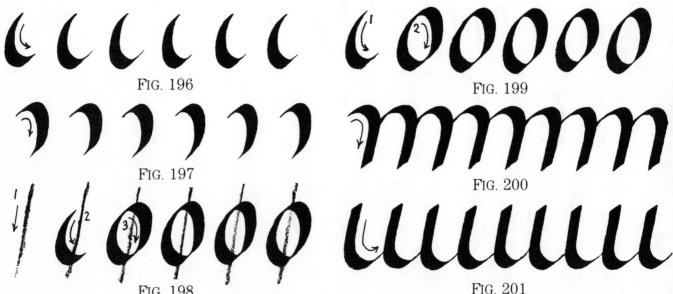

FIG. 196

FIG. 197

FIG. 198

FIG. 199

FIG. 200

FIG. 201

VERTICALS AND HORIZONTALS

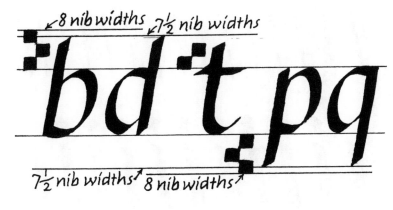

8 nib widths 7½ nib widths

7½ nib widths 8 nib widths

FIG. 202

T HE Italic letters that include vertical strokes with ascenders or descenders are formed much as those in the Roman hand. The ascenders for the letters *b, d, f, h, k,* and *l* extend three nib-widths above the guidelines (Fig. 202); the ascender for the letter *t* only two nib-widths higher. The descenders for the letters *p* and *q* extend three nib-widths below the guideline. As in previous exercises, 7 1/2 nib-widths will be used for the guidelines.

EXERCISES

1. Draw the stroke for the letter *l* (Fig. 203), which is a simple vertical ascender.

2. Draw the letter *i* (Fig. 204), which is a simple vertical stroke five nib-widths high, over which a dot is placed.

3. The horizontal and vertical strokes in the Italic lower case have the same thickness, just as do those strokes in the Roman hand (Lesson 4). This can be checked by drawing a cross (slanted vertical crossed by a horizontal). Compare the slanted "Italic" cross (Fig. 205) with the upright "Roman" cross (Fig. 206). In both, the vertical is the same thickness as the horizontal. But notice how the pen angles differ (Fig. 207).

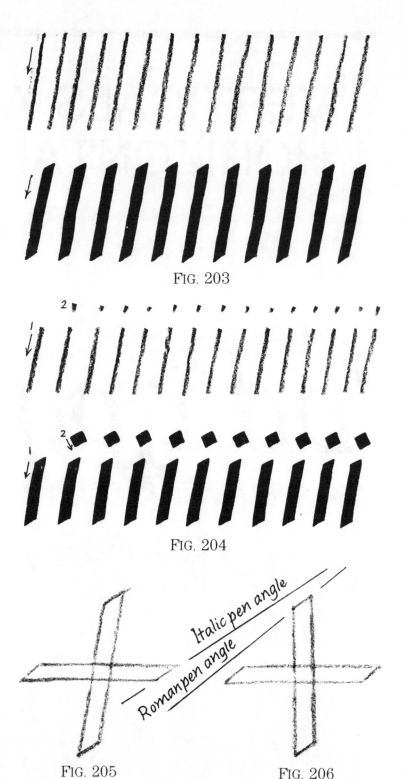

FIG. 203

FIG. 204

FIG. 205 FIG. 206

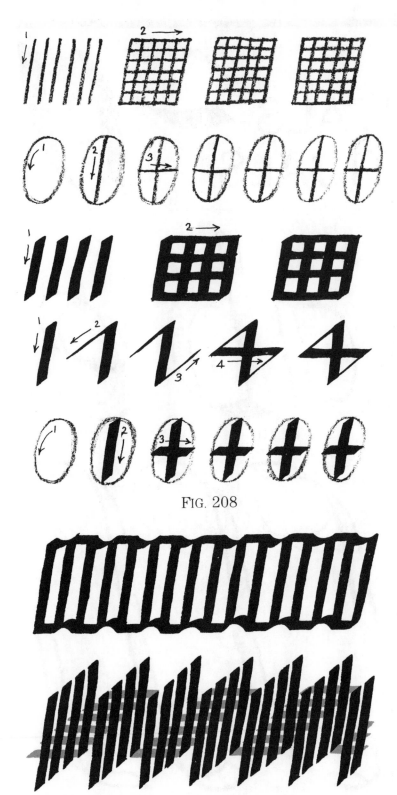

4. Practice, with the use of Italic axes, simple vertical and horizontal strokes, ovals, and other strokes (Fig. 208).

5. Practice the borders in (Fig. 209).

FIG. 208

FIG. 209

CURVED HORIZONTALS AND VERTICALS

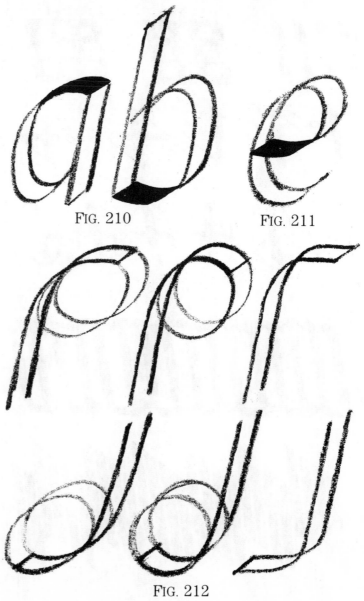

THE straight horizontal stroke is straight and keeps a uniform thickness throughout. The curved horizontal has a slight rise or dip in it and tapers from thick to thin. It joins the oval curve in letters *a, b,* (Fig. 210), *c, d, g, p,* and *q* which are discussed in Lesson 19 on Curves. Its use with the *e,* (Fig. 211), *k,* and *s* is discussed in Lesson 21 on Teardrops.

The curved vertical is as straight as the vertical but the end curves and tapers off into a thin. This can be either at the top or bottom end or, in the case of *f,* both ends. When the curved horizontal meets the curved vertical, they join around a broad oval curve, not a circle or a sharp angle (Fig. 212).

FIG. 210 FIG. 211

FIG. 212

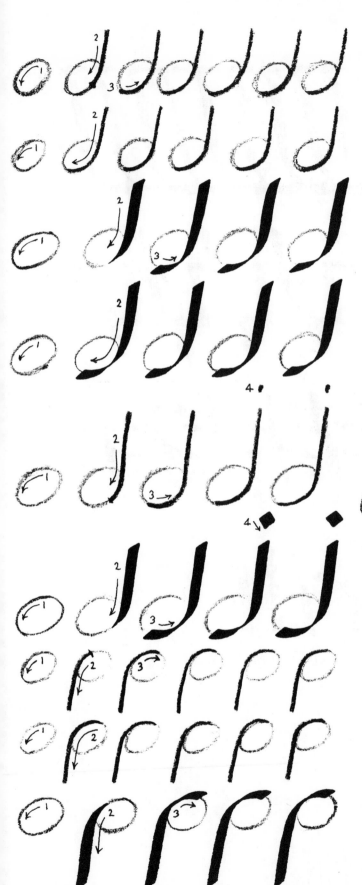

FIG. 213

1. At this stage in learning the Italic, draw all of the strokes down from thin to thick (Fig. 213). Later on, some strokes are pushed up from thick to thin. One example (Fig. 214) has been included in these exercises.

2. Draw the *f* with the horizontal a little below the line (Fig. 215).

3. Draw the *r,* and notice that the vertical is straight, not curved (Fig. 216).

FIG. 214

FIG. 215

FIG. 216

4. Draw borders and a word (Fig. 217) that uses these strokes. With the letters presented so far, we could think of one word, *frill*. Can you think of any others?

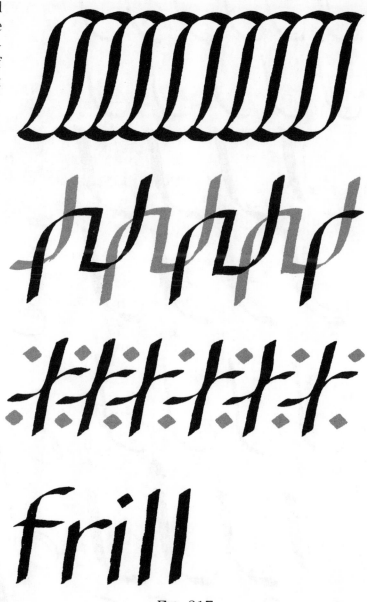

FIG. 217

DIAGONALS

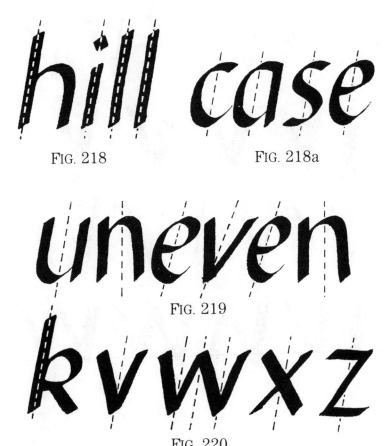

FIG. 218 FIG. 218a

FIG. 219

FIG. 220

As in Lesson 12, the diagonals will be approached by way of the axis. To keep all letters slanted at the same angle, you have to be aware of their axis. For some letters the slanted vertical runs along the axis (Fig. 218). Others have an invisible axis running through their center (Fig. 218a). When letters are drawn with axis slanting in a different direction (Fig. 219), the word will look wrong. Except for *k*, the diagonal letters have an invisible axis (Fig. 220). You can make it visible by drawing it in pencil. Then draw the diagonals around it as you did in Lesson 12.

EXERCISES

1. Draw a connected series of diagonals and axis lines in pencil and ink. The angle formed by the joined diagonals should be bisected by the axis line (Fig. 221).

2. Without axis lines, draw *V*'s and *W*'s (Fig. 222).

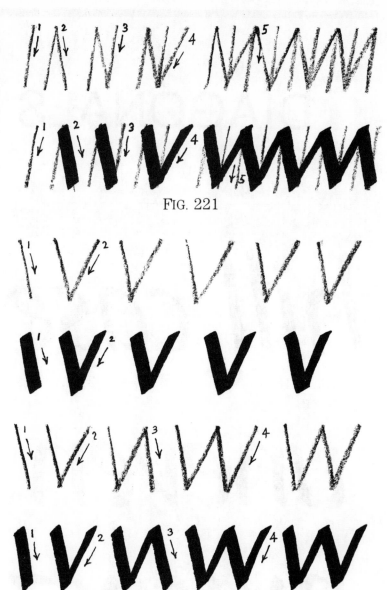

FIG. 221

FIG. 222

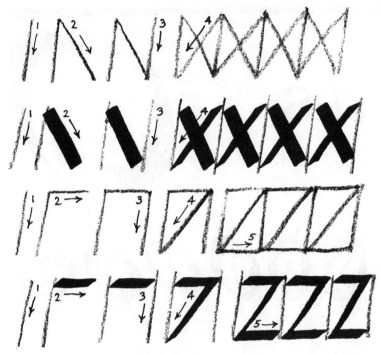

3. For x and z, draw axis lines on the sides of the letter to line up the top and bottom lines (Fig. 223).

4. Draw border designs and words using diagonals (Fig. 224).

FIG. 223

FIG. 224

CURVES

O VALS can be drawn along many different axes. Learn to locate the correct one (Fig. 225).

As you are drawing the curved black line, pay attention to the white shape you are forming inside it (Fig. 225a). If this white shape is an even oval, the outer shape formed by the black lines will be even, too. The axis will divide a properly drawn inner shape symmetrically. Look at the even inner shape in the correct form and the uneven inner shape inside the incorrect form (Fig. 226).

The curved horizontal stroke is added onto the curved stroke (Fig. 227) in all of the letters in this lesson except the *o*. Notice how it does not follow the oval's curve but flattens out.

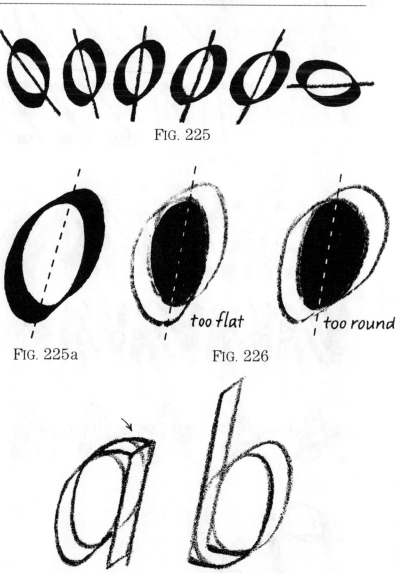

FIG. 225

too flat

too round

FIG. 225a

FIG. 226

FIG. 227

1. Warm up with axis lines and loose ovals. Then draw tight ovals over loose ovals. Finally, do ovals freestanding (Fig. 228).

2. In ink, draw ovals over loose pencil ovals, around axis lines and freestanding (Fig. 229).

FIG. 228

FIG. 229

3. Refer to Figure 227 for joining the curved horizontal stroke to the curved stroke in the *a, b, c, d, g, p, q* (Fig. 230). Add a straight vertical stroke for the *a, b, d, p* and *q*. Add curved vertical and horizontal strokes for the descender of the *g*.

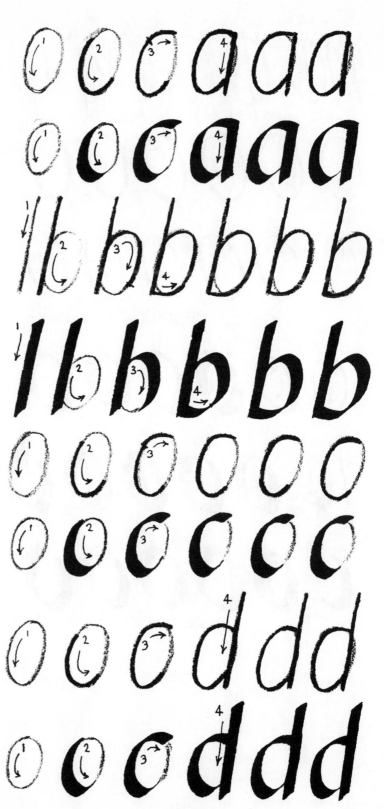

FIG. 230

4. Draw the border designs using the curved strokes (Fig. 230a).

jog
cab
viola

FIG. 230a

FIG. 230 *(continued)*

STRAIGHT AND CURVE

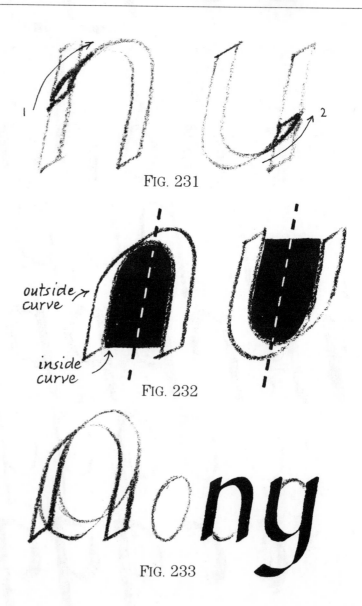

THE strokes in this lesson are combinations of straight and curved strokes. Both straight-and-curves join the vertical (Fig. 231) with a short curve either before the thin (1) or after the thin (2). This short curve is drawn by *pushing the pen up*. In (1), start in the wet ink of the vertical stroke, push up into the thin, and complete the straight-and-curve stroke. In (2), after drawing the straight-and-curve stroke to the thin, push up for a short curve, then draw the vertical down into the wet ink of the short curve. Joining strokes while the ink is wet adds to the fluidity of the drawing.

In joining the vertical stroke, the straight-and-curve forms an arch. The inside shape of the arch is similar to the inside shape of the oval in that both are divided symmetrically by the axis line (Fig. 232). Keep your eye on the formation of an even inside curve, and the outside curve will take care of itself.

FIG. 231

outside curve

inside curve

FIG. 232

FIG. 233

In the exercises, the arch letters are formed around a pencil axis line. You may also want to form them around the oval (Fig. 233).

EXERCISES

1. Draw arches in pencil around the axis line, the oval and freestanding. Then draw them in a continuous series (Fig. 234).

FIG. 234

2. Draw arches in ink in the same sequence (Fig. 235). Keep your eye on the inside curve.

In this continuous series of arches (Fig. 235a), begin pushing the pen up a little for the short curve.

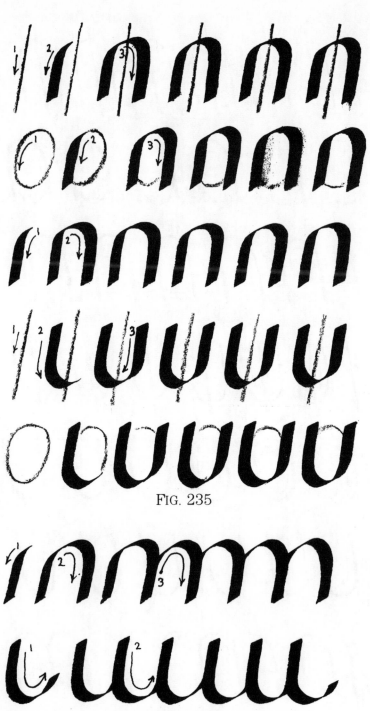

FIG. 235

FIG. 235a

3. Draw the arch around the axis line or the oval—whichever helps you more—for the following letters: *n, h, m, r, u,* and *y.* For the *y,* add a curved vertical and horizontal stroke for the descender (Fig. 236).

4. Draw borders and write out words using the straight-and-curve stroke (Fig. 237).

FIG. 236

FIG. 237

THE TEARDROP

THE letters in this lesson share a *common inner* shape—the teardrop (Fig. 238). Instead of learning the shape of strokes, watch the formation of the white space inside the strokes.

To make an *s*, start with an oval. (1) Draw a wavy line to divide the oval into two equal teardrops (Fig. 239). (2) Add curved horizontal strokes at top and bottom. Notice how these strokes are not as curved as the top and bottom of the oval but flatten out.

To make an *e*, first draw an oval and then a horizontal stroke through it to form a teardrop (Fig. 240). The *k* and ampersand use this same teardrop.

FIG. 238

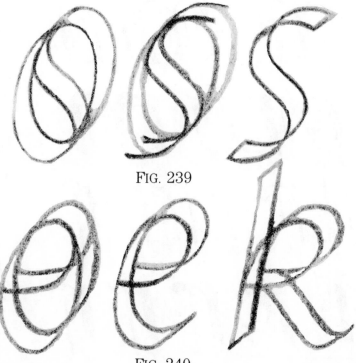

FIG. 239

FIG. 240

116

FIG. 241

EXERCISES

1. Practice the *s*, first within the oval and then around the axis line (Fig. 241). You get a cash bonus because as you draw the *s* around its axis line (in ink), it forms the dollar sign. 2. Practice the *e, k,* and the ampersand as demonstrated in (Fig. 242).

FIG. 242

3. Create borders and words using the teardrop (Fig. 243).

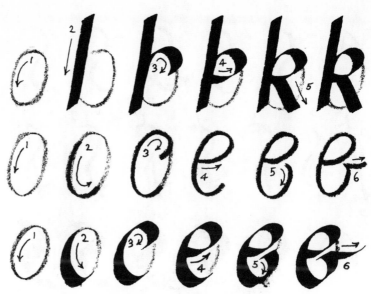

FIG. 242 *(continued)*

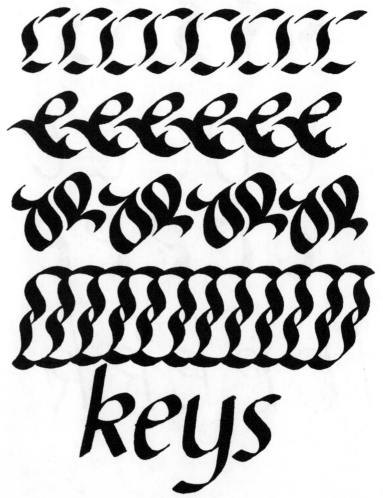

FIG. 243

HOOKS

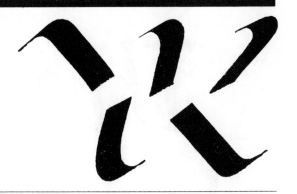

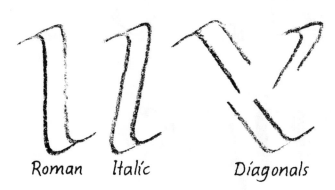

Roman Italic Diagonals

FIG. 244

L IKE the Roman, the Italic letters are finished off with little hooks, and like the Roman they are connectors between the thinnest stroke and the verticals (Fig. 244). Sometimes, when the ink flow in your pen is sluggish, the top hook will get it started.

EXERCISES

Examine "The Quick Brown Fox" (Fig. 245) to see how hooks are attached to the letters, then make a copy. This layout has been centered. In the previous examples of the "Quick Brown Foxes" each line began along the left margin. In Figure 245, however, the words are lined up with the (invisible) center of the page. It may take several tries before you will be able to center all the lines but it's worth the effort because the effect is so very pleasing.

The quick
brown fox
jumps
over the
lazy dog.

FIG. 245

HANDWRITING

IN grade school, handwriting used to be taught first as "printing" and then as "cursive." These distinctions are useful in viewing different applications of the Italic. What you have learned so far, the stroke by stroke method, is like printing. Use this approach for special pieces like an invitation to a party or for posters. You will learn more about elegant Italic for special uses later in the lessons on Refined Italic. To

FIG. 246

learn how to use Italic for everyday handwriting, in the cursive manner, make two adjustments:

(1) Don't take your pen off the paper. Instead of forming letters in three or four strokes, form them in one continuous stroke, or sometimes in two strokes. Until now you have been pulling the pen strokes from top to bottom and from right to left. Now you will have to learn to *push* the penstrokes in places from bottom to top and from left to right. You might try it with a marker but even better is a pencil. Most of our everyday writing is done with a pencil or ball-point pen—so don't hesitate to create the calligraphic forms with these instruments, too. Note that for handwriting, the hooks are dropped from the ascenders and right arm of the *v* and *w*. Also, the dot over the *i* and *j* shows the increased speed of the writing (Fig. 246).

(2) The second adjustment is to connect the letters. Some letters may be connected either on the left or right (Fig. 247). Some just on the left (Fig. 248). Some just on the right (Fig. 249). And some do not have strokes that can be used for connectors (Fig. 250). Sometimes the horizontals on the *t, f, z* work as connectors.

imnux

FIG. 247

jprvwy

FIG. 248

acdeh
klt

FIG. 249

bfgoqsz

FIG. 250

aoa bob coc dod
eoe fof gog hoh
ioi joj kok lol
mom non ooo
pop qoq ror sos
tot uou vov
wow xox yoy zoz

The quick
brown fox
jumps over
the lazy dog.

FIG. 251

Handwriting analysts claim that they can tell a person's character traits by studying his or her handwriting and some analysts even insist that it is possible to modify traits by improving the handwriting. Less controversial is the thesis that learning Italic handwriting can help develop in oneself order and discipline, evenness of temper, inner harmony, and self-confidence. Also traits such as impatience and impulsiveness which cause resistance to learning calligraphic handwriting, can be diminished, by persevering in the practice of calligraphy.

EXERCISES

1. In pencil and pen, write out the full lower case alphabet using the new stroke sequence shown in Figure 246.

2. In pencil and pen, write out the letters with their connectors in Figure 251. Then write out "THE QUICK BROWN FOX" which is also shown in Figure 251. As a calligraphic fountain pen was used in this exercise, the letters are smaller than you are accustomed to seeing them.

aoa bob coc dod
eoe fof gog hoh
ioi joj kok lol
mom non ooo
pop qoq ror sos
tot uou vov
wow xox yoy zoz

The quick
brown fox
jumps over
the lazy dog.

FIG. 251 *(continued)*

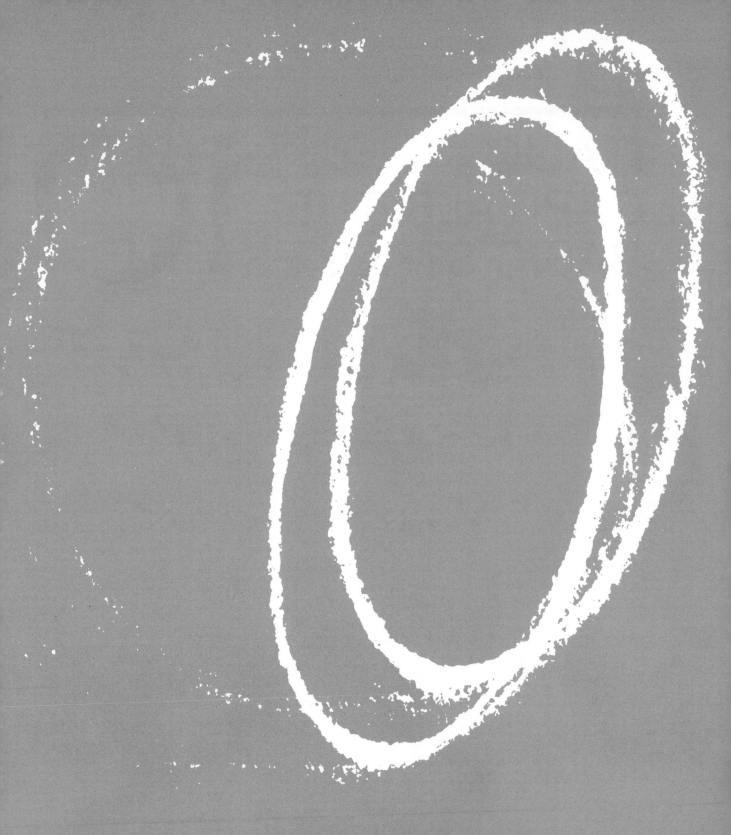

ITALIC CAPITALS

ITALIC CAPITALS: THE BASIC STROKES

T HERE is a shortcut to learning the Italic capitals; as they are similar to the Roman capitals you do not have to go through the stroke by stroke process. Instead, just modify the Roman capitals by condensing them and slanting them to the right.

EXERCISES

Draw a Roman capital inside an upright rectangle. Make the rectangle narrower and tilt it to the right. Redraw the capital inside this condensed, slanted parallelogram and you have the Italic capital (Fig. 252).

FIG. 252

You can use this process on all capitals that have verticals lining up with the axis (Fig. 253). There is another, even easier method to use on oval (Fig. 254) and diagonal (Fig. 255) stroke letters. Start with the axis itself and form the oval or diagonal strokes around it.

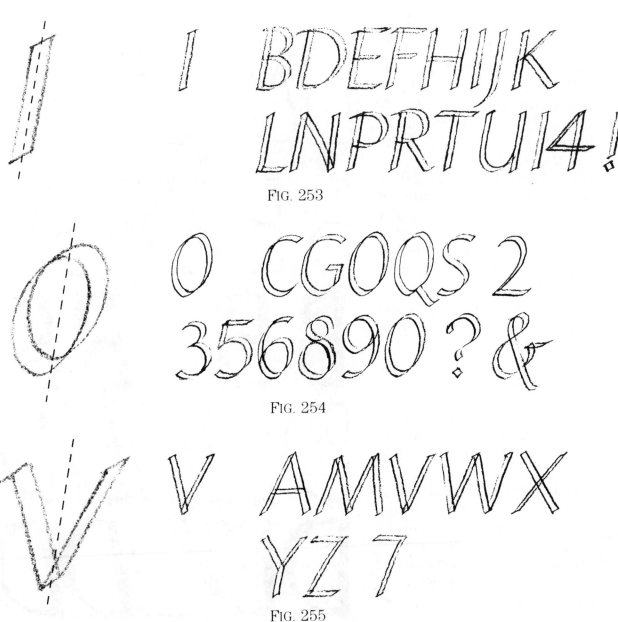

FIG. 253

FIG. 254

FIG. 255

VERTICALS

Each letter in this group has a vertical line which runs down the left side or through the middle of the slanted parallelogram. Once this stroke is made correctly the rest of the letter will follow naturally. The sequence of strokes is the same as for making the Roman capitals, but observe that these letters are narrower than their Roman counterparts. The *B, D, E, F, P* and *R* have a horizontal top stroke which extends slightly to the left of the vertical stroke.

EXERCISES

Draw a few rectangles and parallelograms to feel the difference in width and slant (Fig. 256).

Draw a Roman capital. Pencil a rectangle around it. Then draw a condensed, slanted parallelogram and fit the Italic capital inside, and next to it, do the Italic capital without a parallelogram (Fig. 257). Do

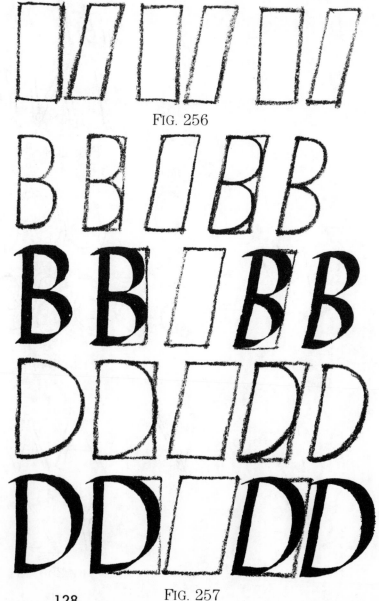

FIG. 256

FIG. 257

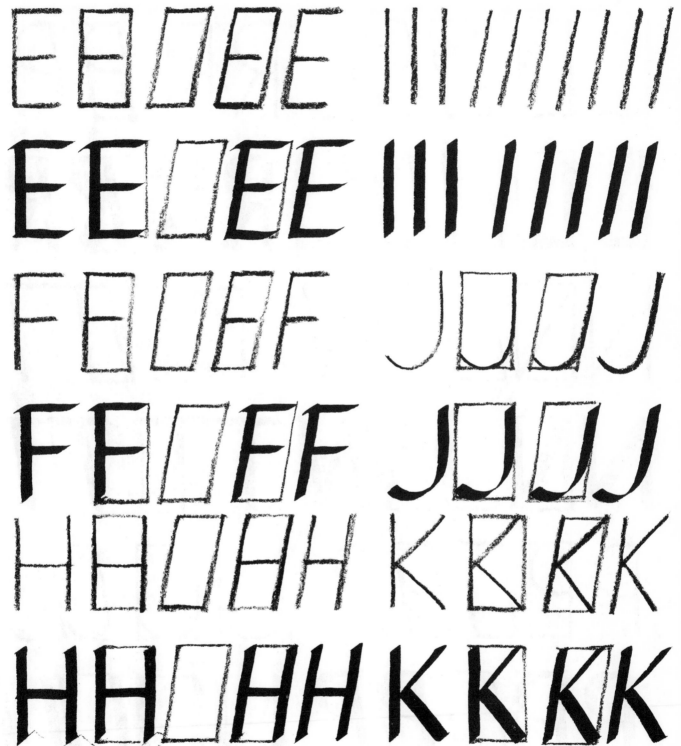

FIG. 257 *(continued)*

FIG. 257 *(continued)*

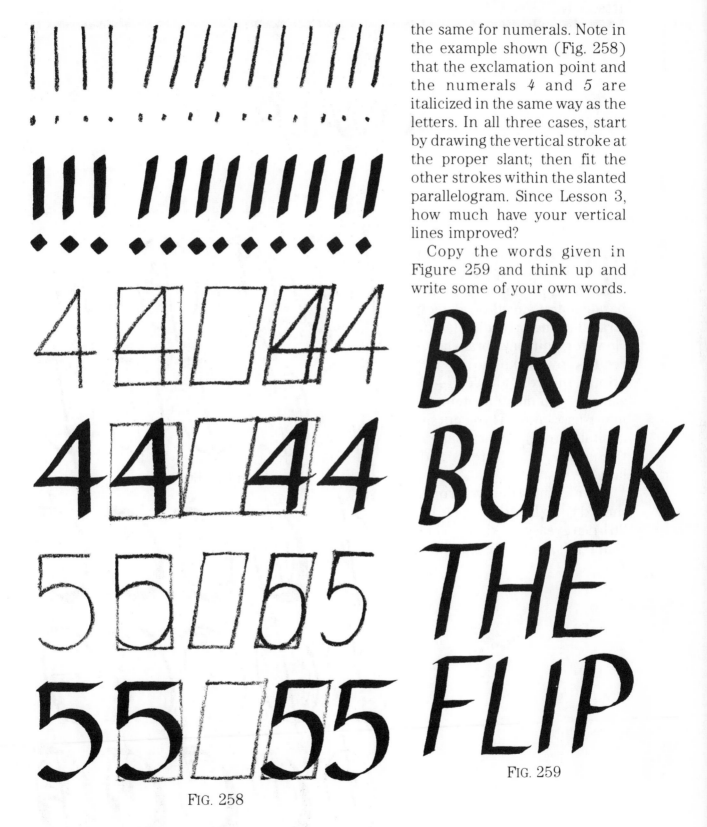

the same for numerals. Note in the example shown (Fig. 258) that the exclamation point and the numerals 4 and 5 are italicized in the same way as the letters. In all three cases, start by drawing the vertical stroke at the proper slant; then fit the other strokes within the slanted parallelogram. Since Lesson 3, how much have your vertical lines improved?

Copy the words given in Figure 259 and think up and write some of your own words.

FIG. 258

FIG. 259

OVALS

THE letters and numerals in this group are created by applying the slanted parallelogram method demonstrated in the preceding lesson. However, you may obtain better results by forming the oval around the axis (Fig. 260)—the same as you did in forming the lower-case ovals. These cursive capitals are the same shape as the lower-case letters, only larger.

After forming the oval around the axis, the letters *C, G, O* (Fig. 261) are easy to draw. Their shape follows the oval directly.

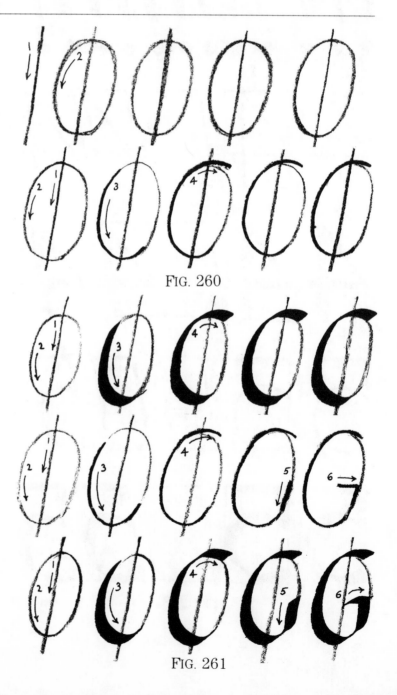

FIG. 260

FIG. 261

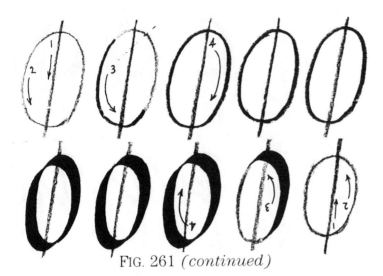

The *S,* the numerals *2, 3, 5, 6, 8, 9,* and the question mark all have small curves that fit within the oval (Fig. 262). (The *5,* which was shown in the last lesson, will give you a chance to compare italicizing figures in slanted parallelograms and in ovals. Use whichever one works for you.)

FIG. 261 *(continued)*

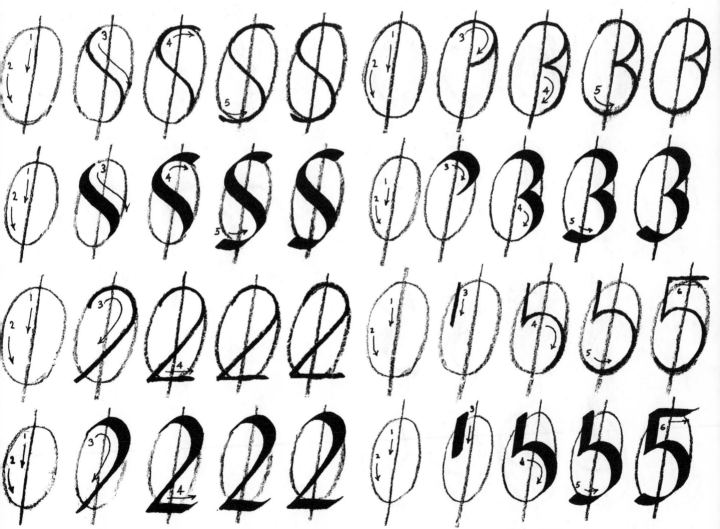

FIG. 262

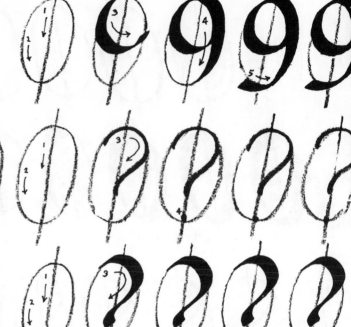

EXERCISES

Applying the "oval-around-the-axis" method write as many words using only italic capitals as you can. Figure 263 is an example of one word.

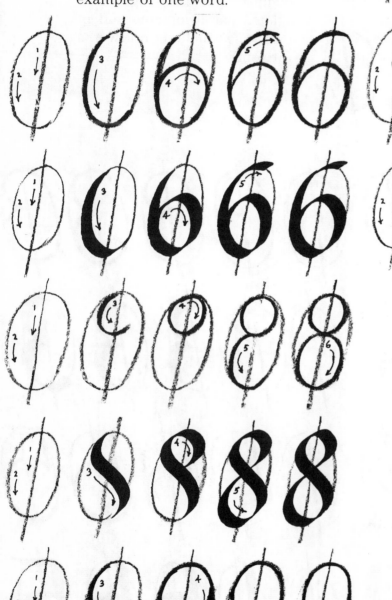

FIG. 262 *(continued)*

COGS

FIG. 263

DIAGONALS

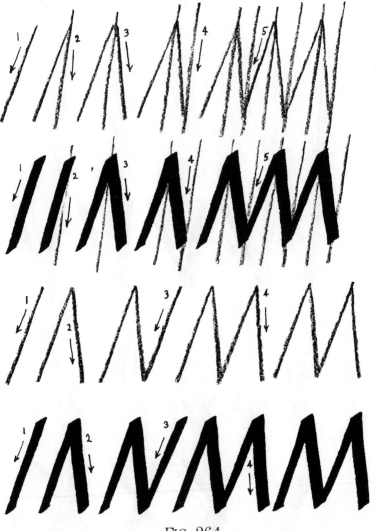

EXCEPT for the *M* and *Y,* the capitals in this group are actually the lower-case letter forms but written larger. As you did with the lower case, first draw the axis going down the middle, and then form the letters around it. With these letters, you have completed the Italic hand!

EXERCISES

Draw diagonal lines (1, 3, 5, etc.) and axes lines (2, 4, etc.) which split the zigs and zags in half. This zigzag is the basis for the *M* and *W* (Fig. 264).

FIG. 264

The diagonal strokes in the *V,
X, Y* and *Z* (Fig. 265) have wider
angles than the *M* and *W*. First
learn how to place the diagonal
strokes symmetrically around
the axis, then adjust the angles.

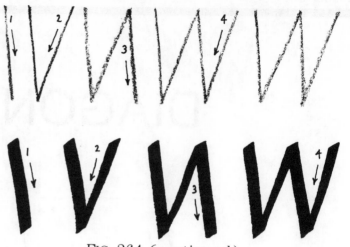

FIG. 264 *(continued)*

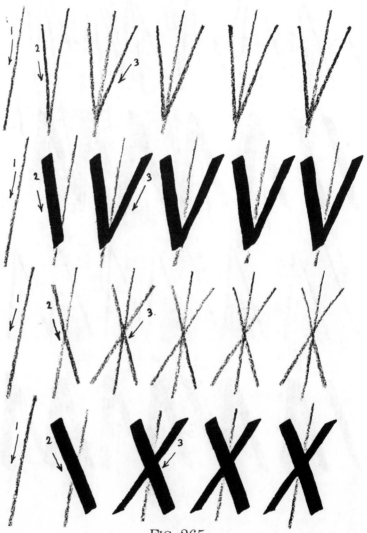

FIG. 265

Copy the words in Figure 266 and also write more words of your own choosing. Use all diagonal capitals in this exercise. Try your hand at writing long sentences.

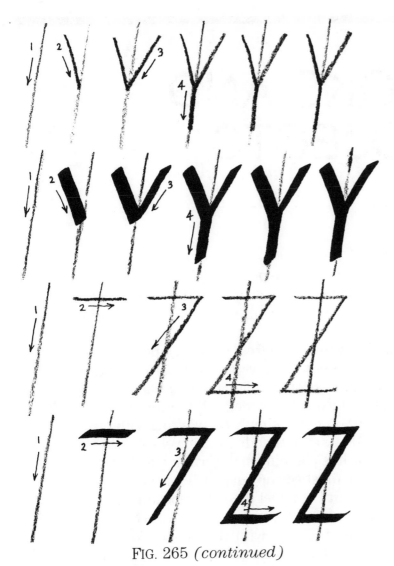

FIG. 265 *(continued)*

ZOOM
COAX

WAVE
JOY

FIG. 266

HOOKS AND PROJECTS

As with the Roman and Italic lower-case letters, hooks also are added to finish off the Italic capitals.

With all the Italic letters at your fingertips, try them on two of the most popular uses of calligraphy: addressing envelopes and wedding invitations.

Some people learn calligraphy just to address the envelopes for an upcoming wedding or special event. To save the time of drawing guidelines on each envelope, professional calligraphers use a variety of tools from T squares to light boxes. These methods require special equipment and an instructor. You might simply try working without lines altogether, the way you have always addressed envelopes.

Doing the invitation takes a little planning in the layout stage but it isn't that difficult. Write out the finished copy in pencil for the layout and then several times in ink until you feel the letters beginning to flow. Take the finished copy to an offset printer to duplicate for the total number of copies you need. Check with the printer for size requirements before you begin. Do your piece in black ink. The printer can use blue, brown, or any color ink on the printed piece, and he may offer a selection of colored papers. For festive occasions, experiment with a variety of colored inks and papers.

EXERCISES

Copy the example given in Figure 267. Do the same for Figure 268. It might take a few tries before you will be able to center the lines in an invitation. Make up invitations to birthday parties, anniversaries, and graduations.

Mr. and Mrs. R. Brown
123 Upland Way
Homer, CA 01314

FIG. 267

You are cordially invited
to the marriage of
Edward Bear
&
April Blue
Sunday, June 3, 10 A.M.
Grace Church
RSVP
Mrs. N. Blue 832-9214

FIG. 268

EXERCISES

Copy "THE QUICK BROWN FOX" (Fig. 269). Notice that except for the O that all the letters take at least one hook. Make up sentences and write them out in Italic capitals with hooks.

THE QUICK BROWN FOX JUMPS OVER THE LAZY DOG.

FIG. 269

Advanced
Forms

ROMAN LOWER CASE: THE SERIF

UNTIL this lesson, the Roman and Italic hands have been presented in a simplified form—using the straight line, circle and oval—for two reasons: so that the student (1) sees the geometric structure of each letter and (2) practices these few basic forms instead of the outward appearances of many different letters. With sufficient practice, hand-eye control develops. When this occurs you will be ready to attempt the variations of letter form presented in this section. Some of these refinements are subtle and require a discerning eye, some require increased manual dexterity. All of them, eventually, become a matter of taste. Refining a craft means refining the craftsman. The more you see, the more you will be able to do. If you can *see* it, you can *do* something about it.

The first of these refinements is the serif. The serif is not structural like the basic strokes, but puts a finishing touch on

FIG. 271

some of those strokes. For a full showing of letters with serifs, see the appendix.

Serifs add character to a calligraphic hand and serve as little connectors between letters (Fig. 270). The top serif picks up where the last letter left off and the bottom serif points the way to the following letter. Sometimes serifs actually touch both the preceding and succeeding letters. Even when they do not touch they make optical connections and create a visual horizontal flow.

There are basically two kinds of serifs—those that go on top and those that go on the bottom.

The serif shown in Figure 271 is used at the top of verticals. The curved stroke wraps around a small circle. It can be formed in two ways illustrated in Figure 271.

EXERCISES

Practice both ways of forming the top serif with pencil and pen. Draw a small circle and wrap the curved stroke around it. A top serif is also used on the *v, w,* and *x.* Sitting on a diagonal line it is formed in the same ways as the vertical serif (Fig. 272).

FIG. 272

EXERCISES

Practice both ways of forming the top serif on the diagonal with pencil and pen. Notice that the circle for the curved stroke is slightly larger than the previous one used for adding a serif to the vertical stroke (Fig. 272a).

The serif in Figure 273 is used at the bottom and is formed around a small circle.

The bottom serif also appears on diagonals k, and x (Fig. 274).

EXERCISES

Practice the bottom serif on vertical and diagonal strokes in both pencil and pen (Fig. 274a).

Now add serifs to the letters in "The quick brown fox" (Fig. 275).

FIG. 272a

FIG. 273 FIG. 274

FIG. 274a

The quick brown fox jumps over the lazy dog.

FIG. 275

ROMAN LOWER CASE: REFINED FORMS

A number of changes are made to affect the *tone* or *color* of a letter. In Figure 276, *a* and *e* are dark in contrast to *b* and *n*. In Figure 277, they blend in evenly. It is desirable to have an even tone throughout your words and paragraphs.

The *a* appears dark because of the small circle. This can be replaced with a teardrop shape (Fig. 278) or a thin diagonal (Fig. 279). The step-by-step formation of the *a* is shown in Figure 280.

FIG. 276

FIG. 277

FIG. 278

FIG. 279

FIG. 280

146

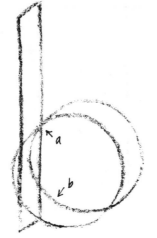

FIG. 281

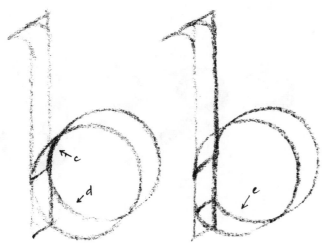

FIG. 282

The *b* (Fig. 281) has a weak top join (a) and a thick bottom join (b). Start by moving the whole circle to the right. Then the top curve (c) flows more gracefully into the vertical but the bottom curve (d) is thicker than before. The way this curve springs from the vertical it follows nature: as when a branch springs from the trunk of a tree it is thicker at the join. This can be corrected by flattening the bottom stroke (e) (Fig. 282). The top curve may seem a little unnatural when you push the pen from the vertical up to the thin (c), but a little practice will take care of that.

This procedure also applies to the *d, g, p,* and *q* (which can have a tail added) (Fig. 283).

bb dd qq ggpp

FIG. 283

The *g* can take an entirely
different shape (Fig. 284). The
bottom is an oval. Notice how
the top and bottom line up. The
sequence of the formation of
this *g* is shown in Figure 285.

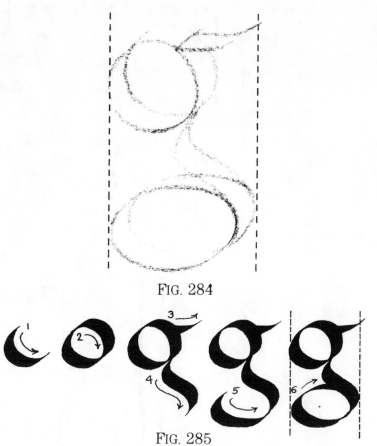

FIG. 284

FIG. 285

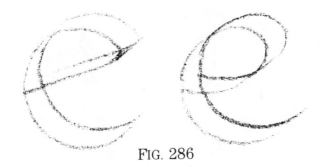

FIG. 286

The crossbar on the *e* may be slanted up or changed into a teardrop shape (Fig. 286).

The feet of several letters (Fig. 287) do not come down straight to the line but curve slightly to the right (1) or become full serifs (2) or have capital serifs added on (3). The construction of the capital serif is explained in Lesson 32.

1 fhkmnpr

2 fhkmnpr

3 fhkmnpr

FIG. 287

The curve can spring from within the vertical (Fig. 288) in the *h, k, m, n, r, u* and *y*. Then the inner shape becomes an even arch. This is demonstrated by the *h* and *n* with serifs in Figure 289.

Another change occurs with the *r* (Fig. 290). Instead of following the circle curve, the top line may flatten out or wave. When some students of calligraphy find out about this wave, they begin flourishing this letter like a flag (Fig. 291). Don't overdo it.

The *k* can be made with a closed, teardrop loop (Fig. 292), and the diagonal can end in a serif.

FIG. 288

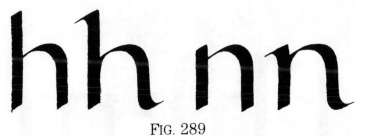

FIG. 289

overdone

FIG. 290 FIG. 291

FIG. 292

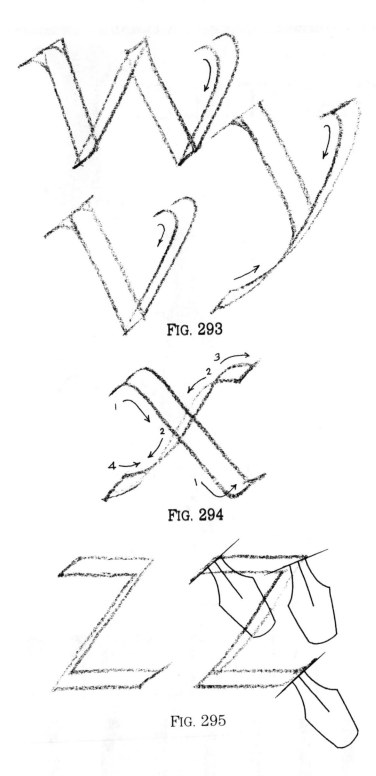

FIG. 293

FIG. 294

FIG. 295

The *v, w* and *y* can have a small serif on the right arm which may curve slightly (Fig. 293). This serif is made in one stroke. The *y,* in a new form based on the *v,* gets a curved bottom stroke.

The *x* can get custom-made serifs (Fig. 294).

When the pen is held at a constant angle, the diagonal on the *z* is too thin. If the angle of the pen is shifted slightly, the diagonal will be a more even match for the horizontals. The shift of pen angle also holds true for the thin diagonals in the *x* and *z* in both Roman and Italic hands (Fig. 295).

ROMAN CAPITALS: THE SERIF

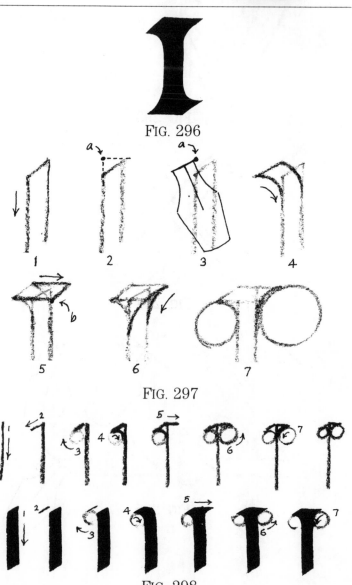

FIG. 296

T HE serifs on the top and bottom of the vertical stroke are like the capital and base of a classical pillar (Fig. 296).

The top serif is formed in six strokes (Fig. 297). (1) First draw the vertical. (2) Find point (a) in the top and left corner. (3) Position the nib on this point. (4) Draw a 1/4 circle into the vertical line and lift the pen. (5) Put the nib back on the starting point and draw a horizontal line to point 6. (6) Draw a 1/4 circle into the vertical line. Notice the difference (7) in the sizes of the two curves.

EXERCISES

It is especially helpful to use the double pencils in learning the capital serifs. Follow the steps shown in Figure 297. Then form the serif in pencil and pen as shown in Figure 298. The

FIG. 297

FIG. 298

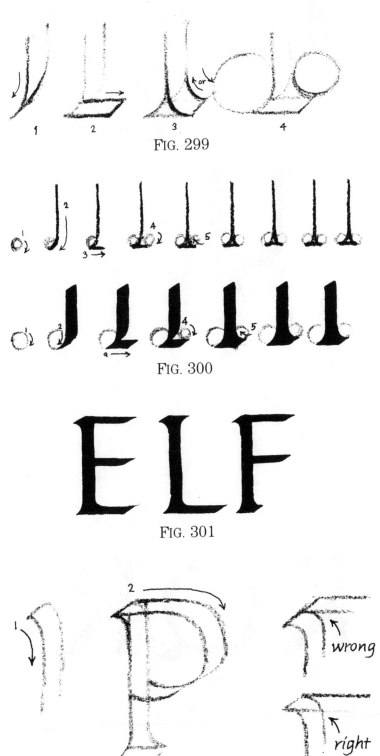

FIG. 299

FIG. 300

ELF

FIG. 301

FIG. 302

bottom serif is a reverse of the top (Fig. 299). It is formed as a continuation of the vertical stroke. (1) As you come to the end of the vertical draw a 1/4 circle to the left. (2) Draw a horizontal line to the right. (3) Draw a 1/4 circle into the terminal. This stroke may be pushed up into the vertical or you can lift the pen and draw down from the vertical into the horizontal. (4) Again, note the difference in curve sizes.

EXERCISES

Draw this serif in double pencils as shown in Figure 299 and then in pencil and pen as shown in Figure 300.

Certain letters do not take the full serif formation (Fig. 301). In *B, D, E, F, L, P,* and *R* the serif is formed only to the left of the vertical.

The top "half serif" starts with the quarter-round stroke (1) and continues down the vertical (2). The top horizontal stroke extends into the rest of the letter (Fig. 302).

The bottom "half serif" in the *B, D, E* and *L* is finished by the

lower horizontal stroke and a little downward curve to fill in the wedge (Fig. 303).

The *U* gets a special 1/2 serif (Fig. 304).

As the "half serifs" are so similar to the full serifs, no separate exercises are necessary.

The serifs in diagonal strokes are formed in the sequence as the vertical strokes. Because of the slant, the curves (and circles) are of a different size. Note the serif on the top of the *M* (Fig. 305). This also is used on top of the *A* and *N*.

A familiar serif (at the end of diagonals) occurs on the *K, Q* and *R* (Fig. 306).

Draw "THE QUICK BROWN FOX" in capital letters with serifs (Fig. 307). As in Figure 177c of Lesson 14 this "QUICK BROWN FOX" has unorthodox word separations, looped letters, etc. and for the same reasons.

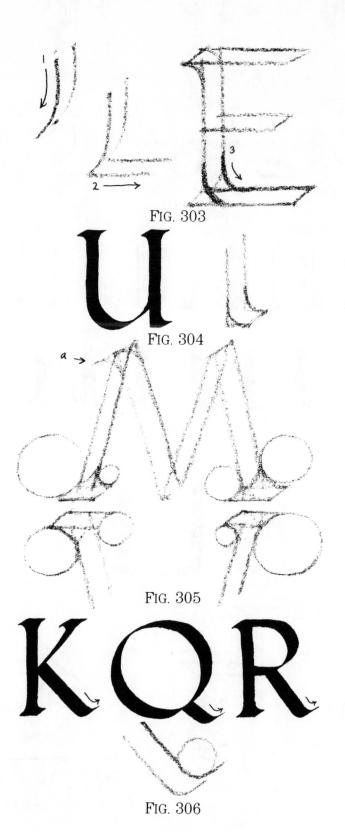

FIG. 303

FIG. 304

FIG. 305

FIG. 306

THE QUIC K BROWN FOX JUM PS OVER *the* LAZY DOG.

FIG. 307

ROMAN CAPITALS: REFINED FORMS

I N the "old rule," the pen angle remained constant and the horizontal and vertical strokes had the same thickness (Fig. 308). A "new rule," for refining all the capitals, shifts the pen angle so that the verticals are thicker than the horizontals (Fig. 309).

There is a change in the *B, S, 3,* and *8* (Fig. 310). These were originally formed around two equal circles (a). Now, make the top one a little smaller and the bottom one larger (b).

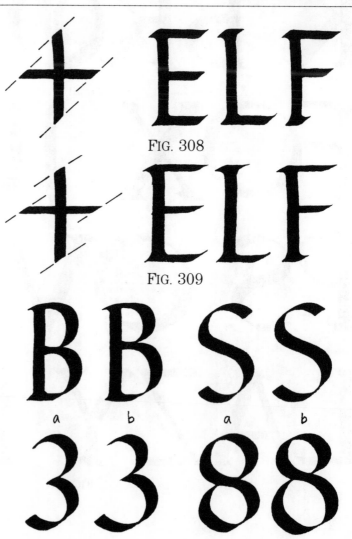

FIG. 308

FIG. 309

FIG. 310

156

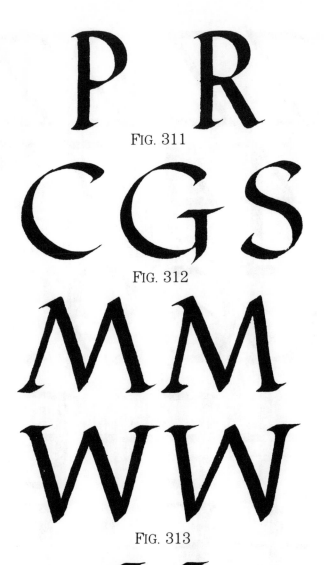

FIG. 311

FIG. 312

FIG. 313

FIG. 314

Use these two new sizes on the *R* and *P;* the *R* gets a little smaller and the *P* larger (Fig. 311).

Add hooks to the *C, G* and *S* (Fig. 312). Add tails to the horizontal and vertical of the *G.*

Instead of forming the *M* and *W* upon equilateral triangles, straighten up the outer legs (Fig. 313).

The *U* may be drawn without the right vertical extending to the bottom (Fig. 314).

When the diagonal is drawn in the *Z, 2, 4,* and *7* (Fig. 315) with a constant pen angle, it is too thin in contrast with the other strokes. Shift the pen angle to make this stroke heavier.

Draw the *6* and *9* within an oval instead of a circle (Fig. 316).

EXERCISES

All the characters in Figure 317 involve subtle hand movements that require you to make choices according to your personal taste. It is not necessary to do each small gradation. Do as many as you can *see* make the difference.

FIG. 315

FIG. 316

FIG. 317

33333 7777

8888 6666

PPPPP 9999

RRRR 2222

MMM 4444

WWW

FIG. 317 (continued)

ZZZZ

REFINED ITALIC: LOWER CASE

T HERE are two elements that distinguish the refined Italic lower case: (1) flourishes on all ascenders and descenders and (2) instead of an oval, the basic shape is a rounded triangle.

The flourishes are formed by the curved horizontal and vertical strokes (Fig. 318) which were presented in Lesson 17. The only new descender is on the *f,* and an alternate *y* (Fig. 319) form based on the *v*. Although they are easy enough to add, the flourishes provide a distinctive ornamental feature to the Italic.

FIG. 318

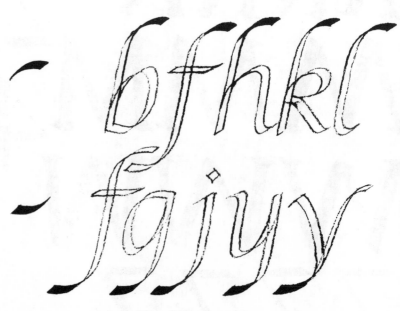

FIG. 319

160

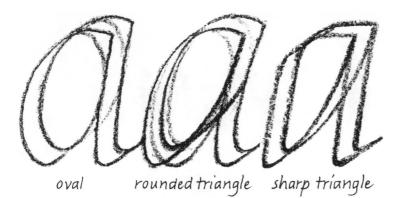

oval rounded triangle sharp triangle

The basic difference in the refined Italic is structural: the oval is replaced by a triangle with rounded corners. You can modify the oval to this new shape by making two changes: (1) flatten the downstroke and (2) tighten the curve (Fig. 320).

The triangle used in the *a, d, g,* and *q* (Fig. 321) is turned upside down for the *b* and *p* (Fig. 322).

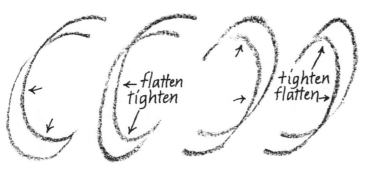

FIG. 320

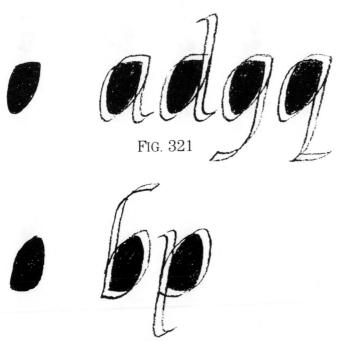

FIG. 321

FIG. 322

The same triangle with an open end can be seen in *h, m* and *n* (Fig. 323).

It is turned upside down in the *u* and *y* (Fig. 324).

EXERCISES

Shape the triangle around the oval. In Figure 325 notice that strokes 2 and 3 (except for the curve at the bottom) are the same as the flourish made up of a curved horizontal and vertical.

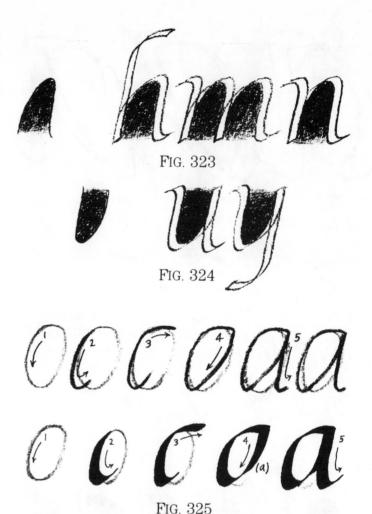

FIG. 323

FIG. 324

FIG. 325

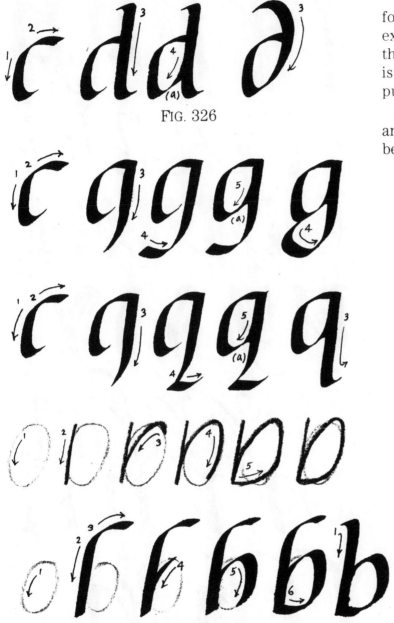

FIG. 326

FIG. 327

Alternate forms are presented for most of the letters in these exercises. Note stroke (a) in these letters. As demonstrated it is drawn down but may also be pushed up.

Stroke 3 in the pencil version and stroke 4 in the pen can also be pushed up (Fig. 327) This

also applies to the *p, n, h* and *m* (Fig. 328). These are the only changes in the lower case. The other letters are the same as before. Copy "The quick brown fox" (Fig. 329) and then write out your own phrases and sentences using the refined Italic lower case.

FIG. 328

The quick
brown fox
jumps
over the
lazy dog.

FIG. 329

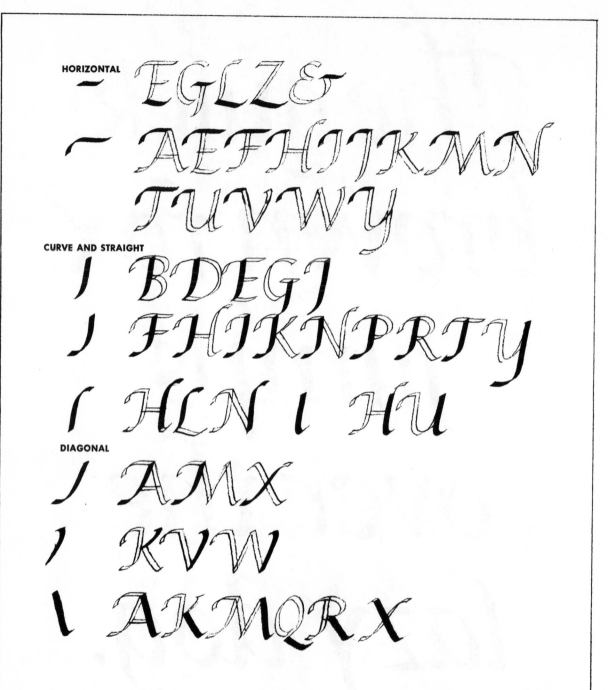

FIG. 330

REFINED FORMS:ITALIC CAPITALS

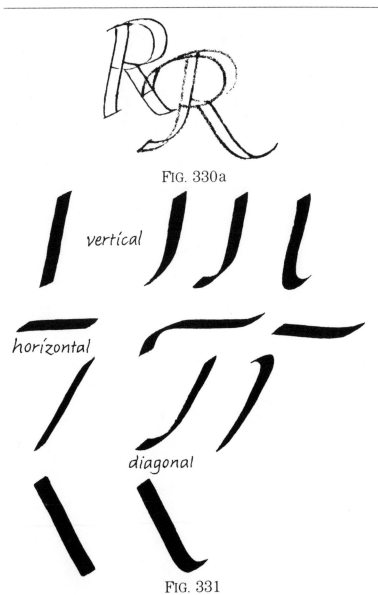

FIG. 330a

vertical

horizontal

diagonal

FIG. 331

T HE Italic letters do not use the serifs of the Roman hand. Instead, their strokes are finished off with flourishes and hooks (Fig. 330). Finishing strokes, either serifs or flourishes (Fig. 330a), alter the appearance of letter forms much as clothes do for the human form. Two men, one wearing a derby and the other a feathered headdress, will cast two different shadows and give the impression that the men are very different people. However, in the light, it may turn out that they are identical twins. Serifs and flourishes are like clothes worn by letters to create character.

Italic capitals are especially decorative and add flair to any piece. They are sometimes used with the Roman lower case, for instance, as initial capitals in lines of poetry. Despite their dashing appearance, they are made up of strokes you already know (Fig. 331). Their basic structure is the same as the Italic capitals presented in

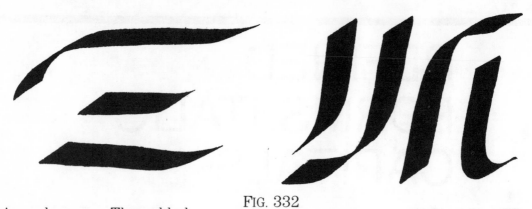

FIG. 332

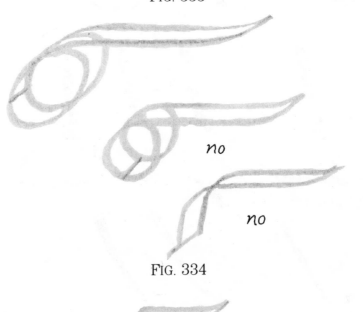

FIG. 333

previous lessons. The added flourishes are also familiar strokes—but done with a twist.

Refined Horizontal and Vertical Strokes

The horizontal and vertical strokes (Fig. 332) are almost the same as the curved horizontal and vertical strokes described in Lesson 17.

The horizontal flourish which leads into these capitals is their most distinguishing feature (Fig. 333). It is part of the structure of *E, F, J, T* and *Z* and an ornamental addition to *A, H, K, M, N, U, V, W* and *Y*.

This flourish begins with a broad curve and ends with a slight upward turn. The curve is formed around an oval, not a circle or sharp angle (Fig. 334).

The cross bar on the *E, F, G* and *H* may be a regular horizontal stroke or it may turn up at the end (Fig. 335).

The bottom-line horizontal on the *E, L* and *Z* may be drawn either on the guide line or it may dip slightly below it (Fig. 336).

no

no

FIG. 334

FIG. 335

FIG. 336

The verticals end in the same oval curve. The flourish does not exactly follow the oval shape but flattens out (Fig. 339). In two letters, *H* and *U,* a hook is added.

EXERCISES

Draw the horizontals shown in Figures 337 and 338. To get the feel of the proper curve, make some improper ones—around a circle and around a sharp angle (Fig. 337). When you get to know the look and feel of the wrong ones, you will be better able to distinguish and draw the correct ones.

To dip below the line or make the slight upturn (Fig. 338), it helps to hold the pen with a loose grip.

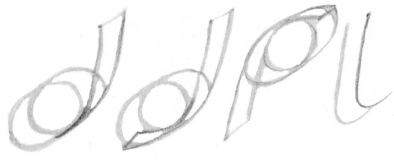

FIG. 337

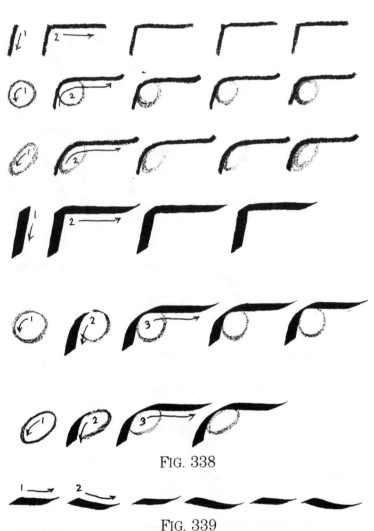

FIG. 338

FIG. 339

More than half the capitals begin with a combination of the horizontal and vertical strokes. You can learn the relationship of these two strokes by shaping them around the oval (Fig. 340).

EXERCISES

Draw the combination or horizontal and vertical strokes around a pencil oval as shown in Figure 341. Then draw the *E, F, H, I, J, L* and *T.*

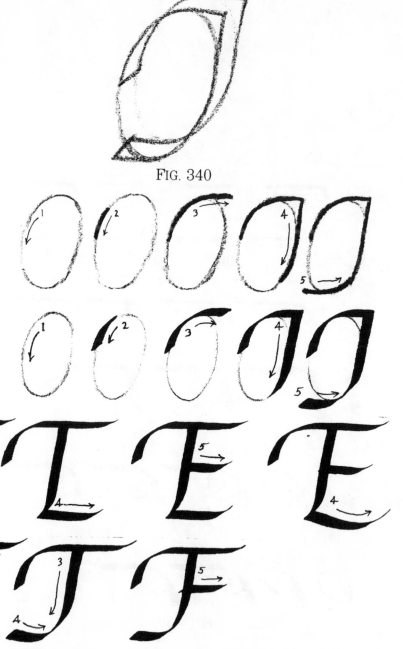

FIG. 340

FIG. 341

The *E* and *L* have alternate forms which dip below the line.

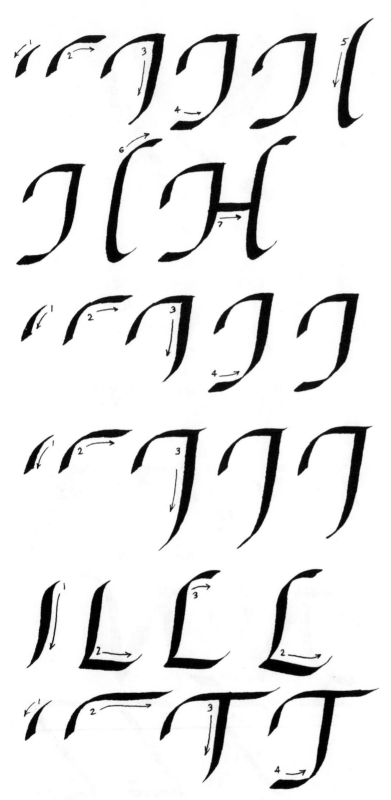

FIG. 341 *(continued)*

Refined Diagonals

Initially, to draw diagonals, it is helpful to angle them in relation to the axis. Later, you will be able to tell if they are being drawn to the correct angle by watching the thickness of line (Fig. 342).

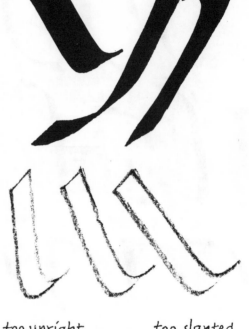

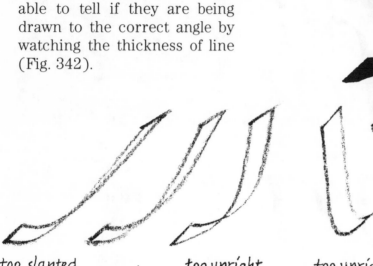

too slanted too thin correct too upright too thick too upright too thin correct too slanted too thick

FIG. 342

EXERCISES

Copy the *N* and *Z* (Fig. 343) and note that the diagonal strokes do not change in these capitals. The *Z* may dip below the line.

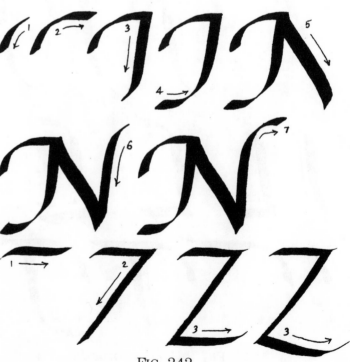

FIG. 343

Hooks are added to the *K, V,* and *W* diagonals (Fig. 344).

EXERCISES

Copy these letters and add the hooks.

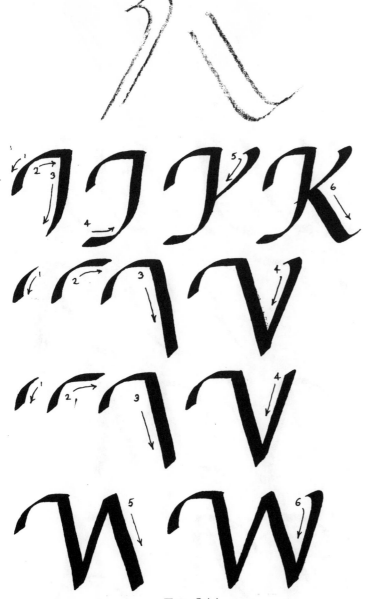

Fig. 344

Hooks and curved horizontals are added to the *A, M,* and *X* (Fig. 345). Practice the difference between the sloped vertical and the diagonal with an attached curved horizontal stroke.

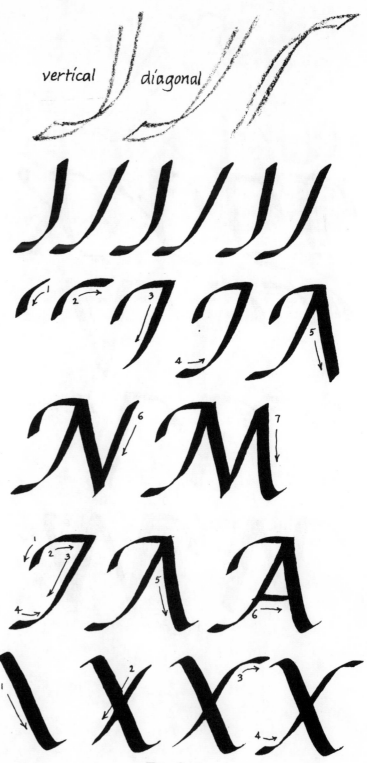

FIG. 345

Royal Royal
Royal Royal
Royal Royal
Royal

FIG. 346

The diagonal is the stroke most frequently elongated into a decorative swash. Actually, the swash can begin in any ascender or descender—but don't overdo it! If you use every swash possibility, your piece will probably get too busy and may obscure the words. Learn restraint. Experiment to find the right possibilities for well-placed swashes which will set off the piece (Fig. 346). Some of you may begin to play with swashes at this stage and some may want to develop your hand and eye coordination before trying out these decorative strokes. There is no need to rush into it. When you are ready, you will know it.

Refined Curves and Ovals

The flourish that leads into the *B, P* and *R* (Fig. 347) is formed

FIG. 347

around a large oval and becomes part of the structure of these letters.

EXERCISES

Starting with two pencil ovals for the *B,* and a single pencil oval for the *P* and *R,* follow the examples in Figure 347.

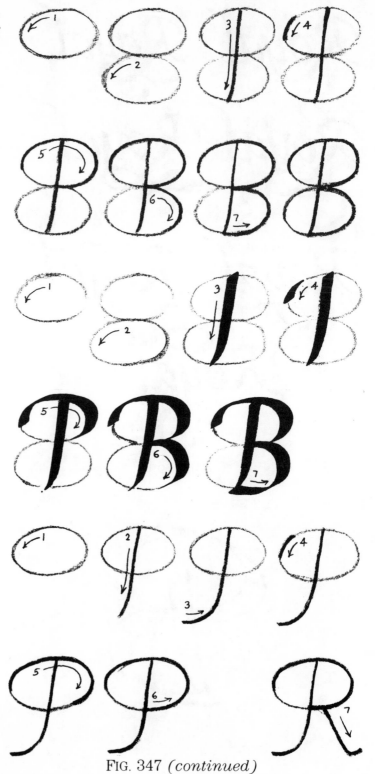

FIG. 347 *(continued)*

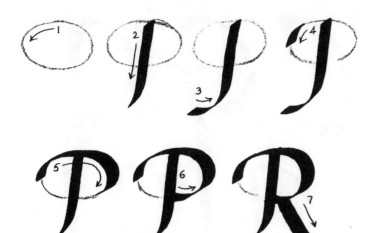

FIG. 347 *(continued)*

The flourish leading into the *D* is formed around a large oval (Fig. 348).

EXERCISES

Starting with the large pencil oval, draw the *D* with the flourish as shown in Figure 348.

FIG. 348

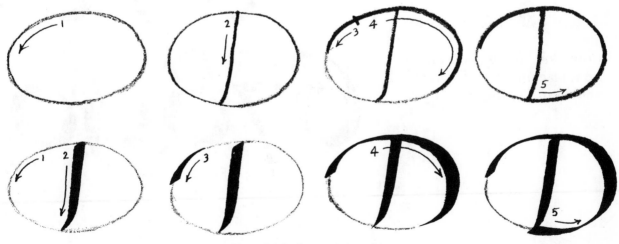

FIG. 348 *(continued)*

There are no significant changes with the other curved or oval capitals.

The *C* may be elongated. The tail on the *G* may be lengthened. The *Q* has an alternate form (Fig. 349).

The *U* and *Y* have flourishes added (Fig. 350). The *O* and *S* stay the same.

The ampersand gets a new look (Fig. 351).

EXERCISES

Copy the changed forms as shown in Figures 349-351.

Refined Numerals

The numerals are not formed differently, but they get a distinctive look by a new placement (Fig. 352). The *1, 2* and *0* are shortened to lower-case height; the rest remain at capital height.

EXERCISES

Copy the numerals with their new placement and heights as shown in Figure 352.

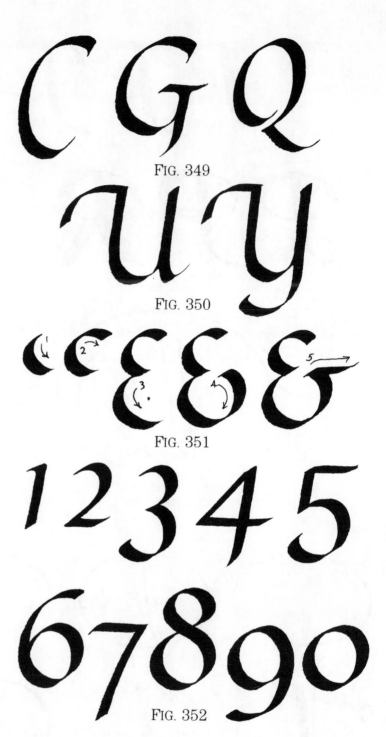

FIG. 349

FIG. 350

FIG. 351

FIG. 352

A PROJECT OF REFINED FORMS

THE quotation in Figure 353 employs the serifs and advanced forms of the Roman hand.

A F·R·I·E·N·D
is one who inces-
santly pays us the
compliment of
expecting from us
all the virtues, and
who can appreciate
them in us.

Thoreau

FIG. 353

CONCLUSION

A conclusion can mark a new beginning. The end of one stage of learning can be the start of another stage. So let's review where you are at this stage, what you have learned up to now and where you are going from here.

In the beginning exercises, you learned the shapes of the basic strokes and formed them upon the internal structures. You watched these strokes take shape as they were drawn in ink (Fig. 354).

Gradually, some internal structures dropped away and you learned to position strokes and form letters around the axis lines (Fig. 355).

Finally you were shown how to form strokes around the space within the letter which is white (Fig. 356). This was only pointed out for a few letters but it exists inside every letter (except for the *i* and *j*). This unit of space is called a counter. In the *o,* it is a closed counter. In the *c,* it is an open counter. For the reader of calligraphy, the

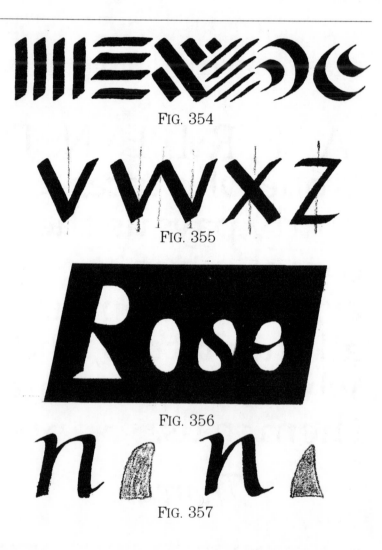

FIG. 354

FIG. 355

FIG. 356

FIG. 357

The quick brown fox

FIG. 358

counters are invisible. For the calligrapher, they are the forms around which the letters are molded. The more clearly you are able to see them, the finer your letter forms will become. The counters of the four letters in Figure 356 have been left in white. Can you make out the word they spell?

If you are having trouble with any particular letter (for instance *n*), return to the lesson in which it was presented. Tape tracing paper over the letter in the book and color in the counter in red. Then tape tracing paper over your own *n* and color in its counter. Compare the red shapes of both counters as shown in Figure 357 and make adjustments.

The counters will also give you the key for positioning your letters next to each other. Balance the space within the letters and the space between the letters and your words will have an even tone. Double the space between letters for the space between words. Imbalance in spacing will result in dark or light spots in your text (Fig. 358).

Observe how this concept of balance and imbalance works when different strokes—vertical, diagonal and curved—are placed side by side (Fig. 359). Space within the letters. Space between the letters. Space between the lines. The viewer sees your text in relation to the white page. Give it generous margins. The guide line sheets in the Appendix were designed for use with 8 1/2″ x 11″ pages. They provide for ample margins. Long before you gain control over the letter forms, if you position the letters evenly in space, the resulting "color" will improve the overall look of your pieces.

Space is also the key to the peacefulness inherent in this practice. As you form your letters, put your attention on the white space. Then see.

FIG. 359

Appendix

AXIS SHEETS FOR ROMAN LETTERS

AXIS SHEETS FOR ROMAN LETTERS

AXIS SHEETS FOR ITALIC LETTERS

AXIS SHEETS FOR ITALIC LETTERS

RECTANGLES

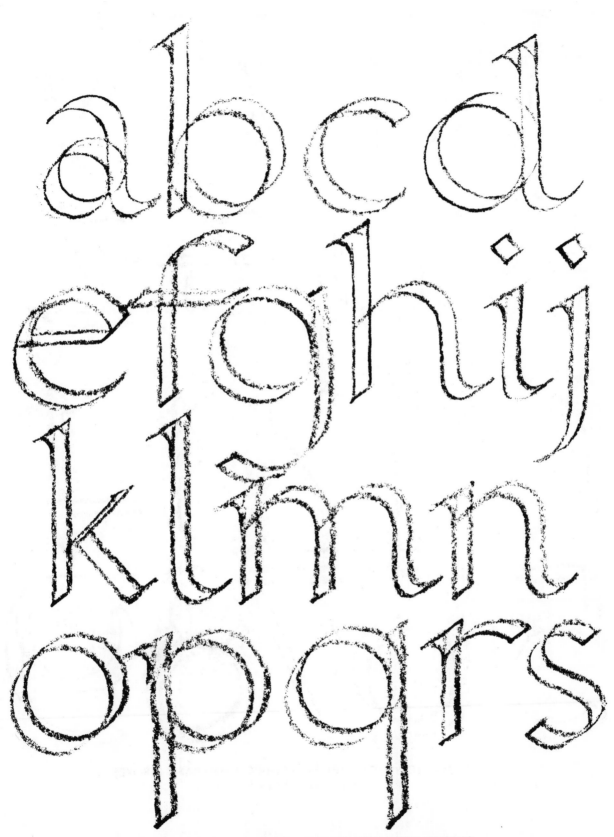

ROMAN LOWER CASE LETTERS WITH COMMON BASIC STROKES
DRAWN WITH TWIN PENCILS

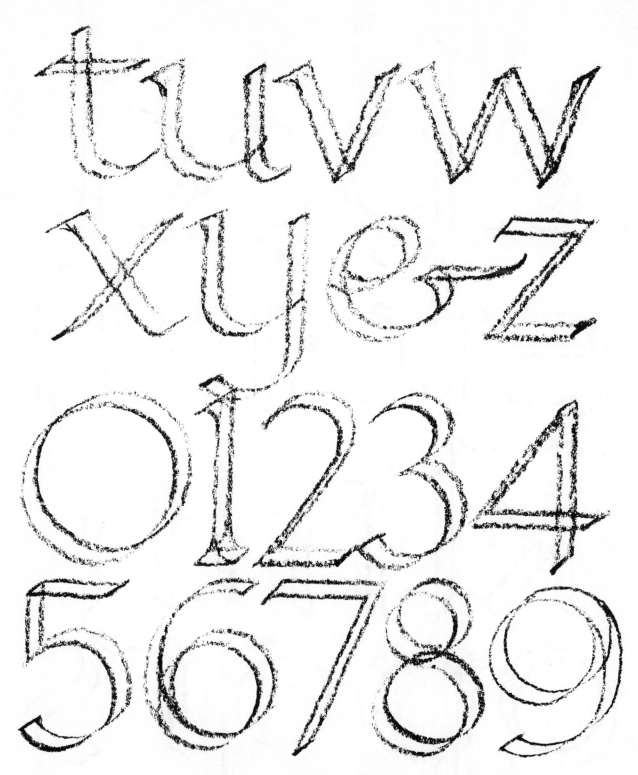

ROMAN LOWER CASE LETTERS WITH COMMON BASIC STROKES
DRAWN WITH TWIN PENCILS

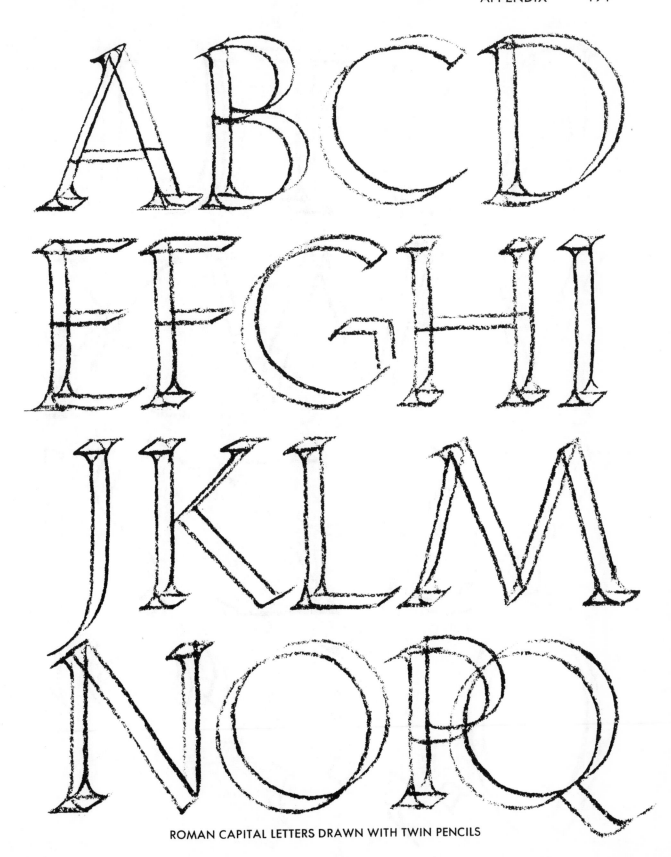

ROMAN CAPITAL LETTERS DRAWN WITH TWIN PENCILS

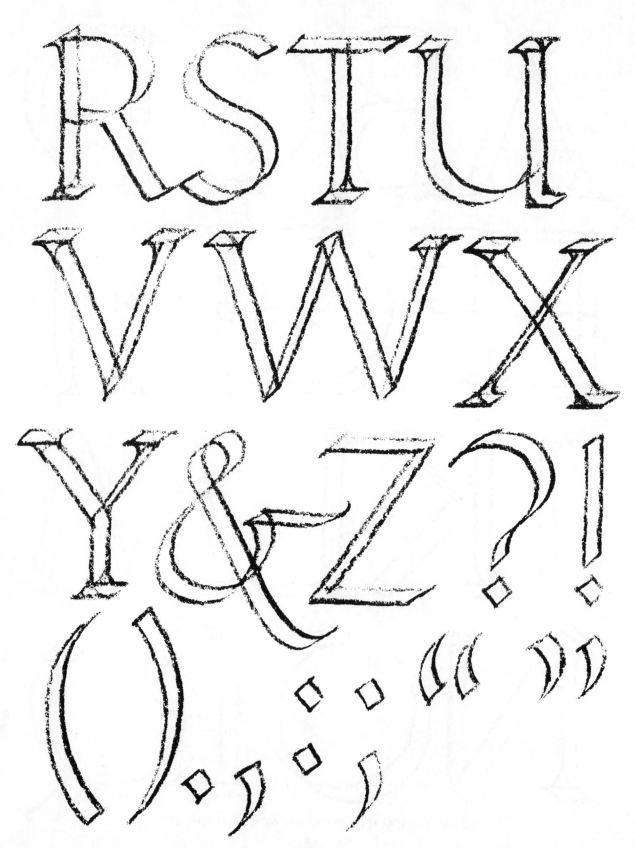

ROMAN CAPITAL LETTERS DRAWN WITH TWIN PENCILS

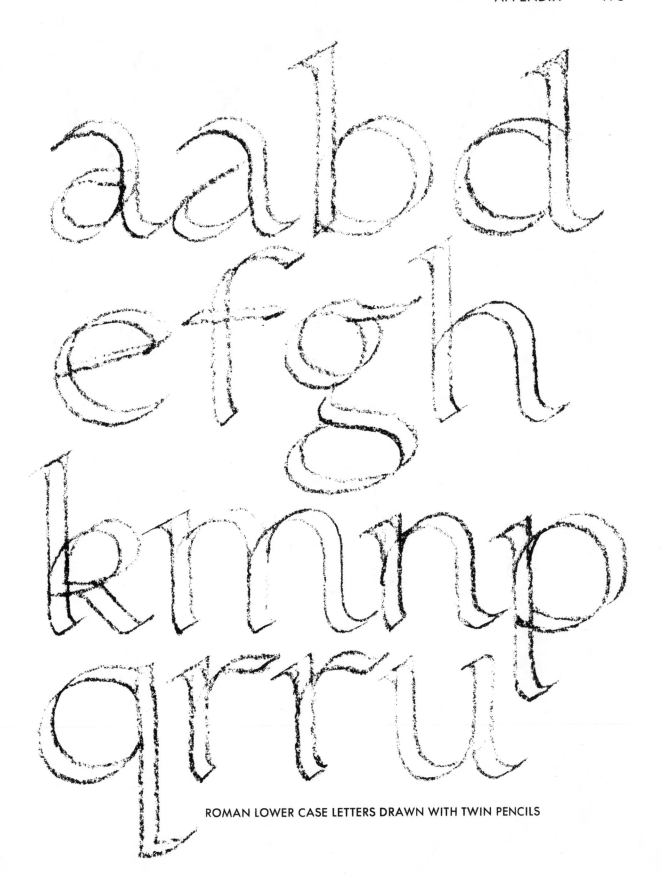

ROMAN LOWER CASE LETTERS DRAWN WITH TWIN PENCILS

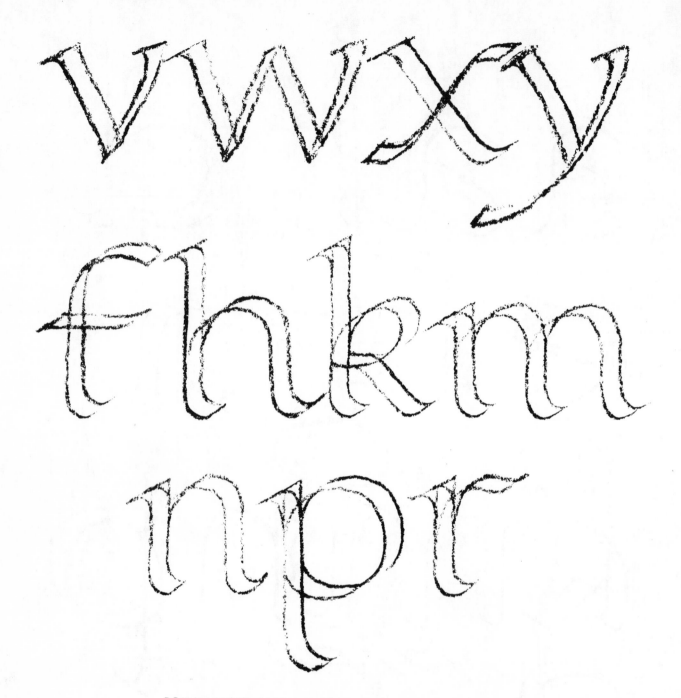

ROMAN LOWER CASE LETTERS DRAWN WITH TWIN PENCILS

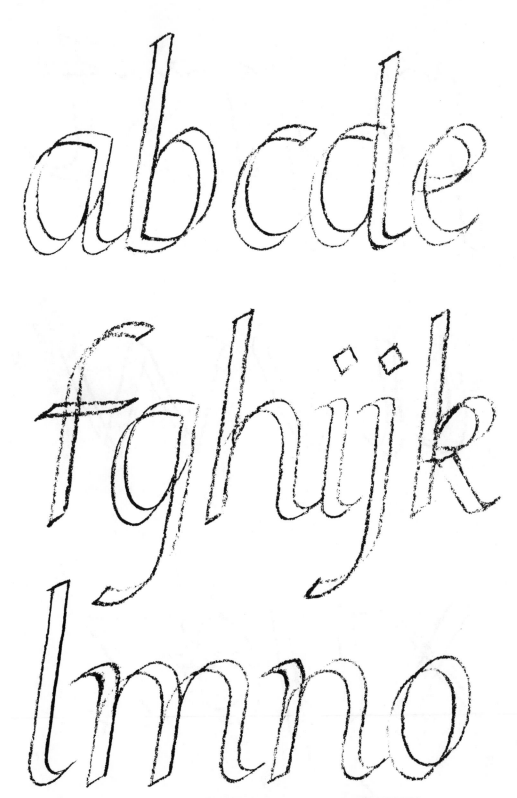

ITALIC LOWER CASE LETTERS DRAWN WITH TWIN PENCILS

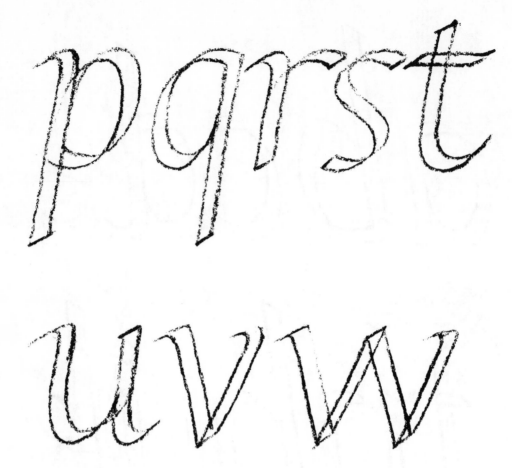

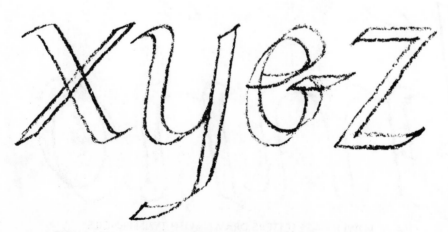

ITALIC LOWER CASE LETTERS DRAWN WITH TWIN PENCILS

ABCDE

FGHIJK

LMNOP

ITALIC CAPITAL LETTERS AND NUMERALS DRAWN WITH TWIN PENCILS

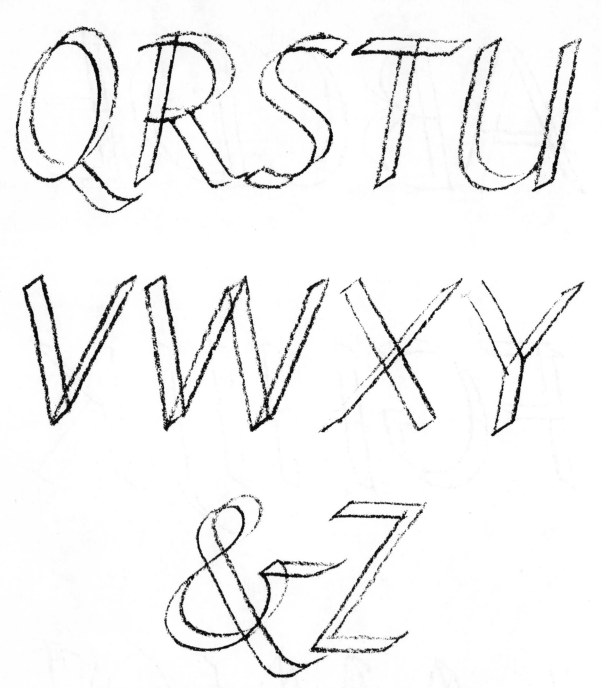

ITALIC CAPITAL LETTERS AND NUMERALS DRAWN WITH TWIN PENCILS

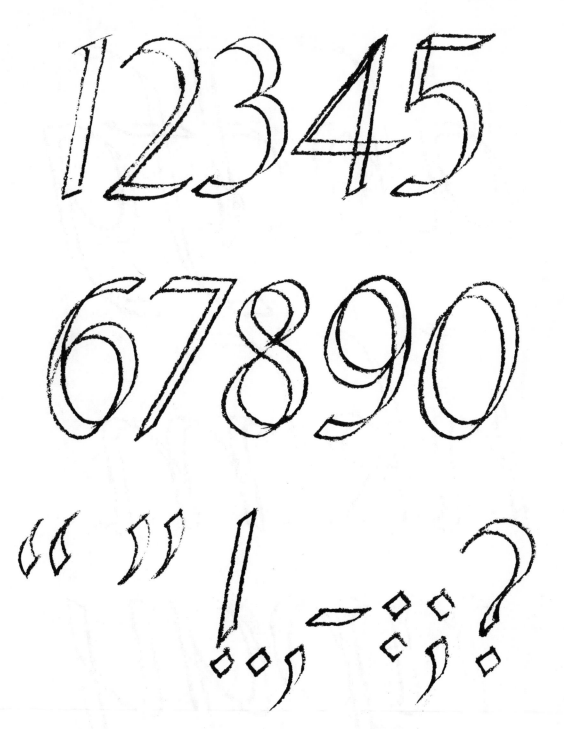

ITALIC CAPITAL LETTERS AND NUMERALS DRAWN WITH TWIN PENCILS

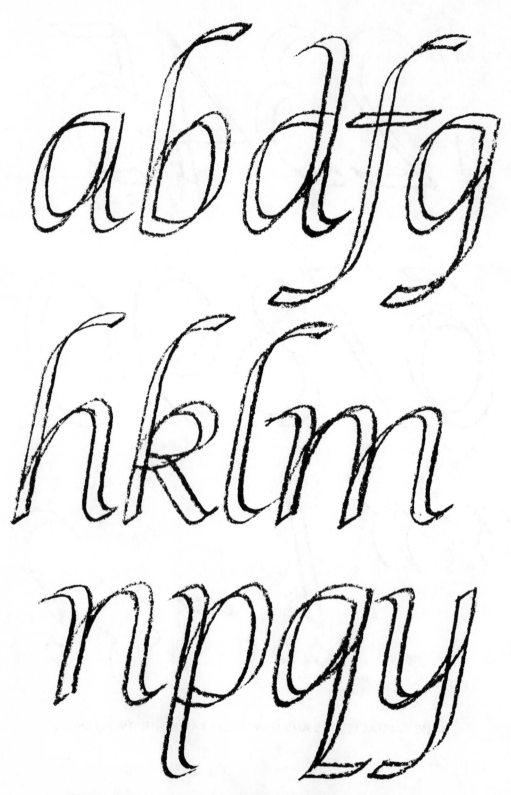

ITALIC LOWER CASE REFINED FORMS DRAWN WITH TWIN PENCILS

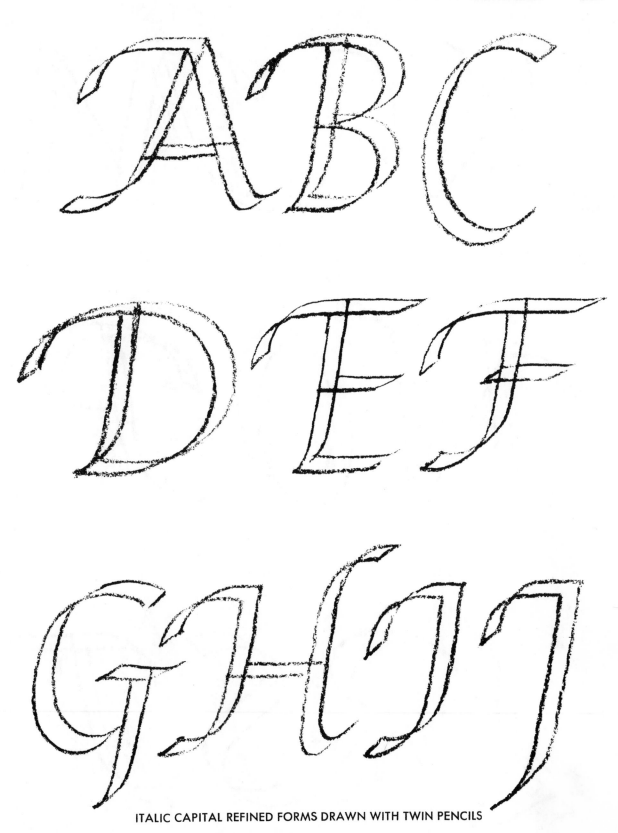

ITALIC CAPITAL REFINED FORMS DRAWN WITH TWIN PENCILS

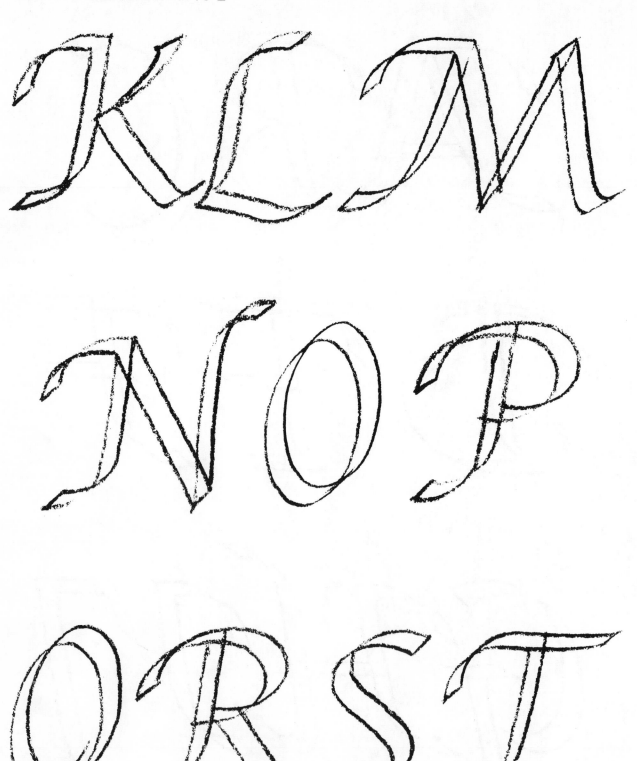

ITALIC CAPITAL REFINED FORMS DRAWN WITH TWIN PENCILS

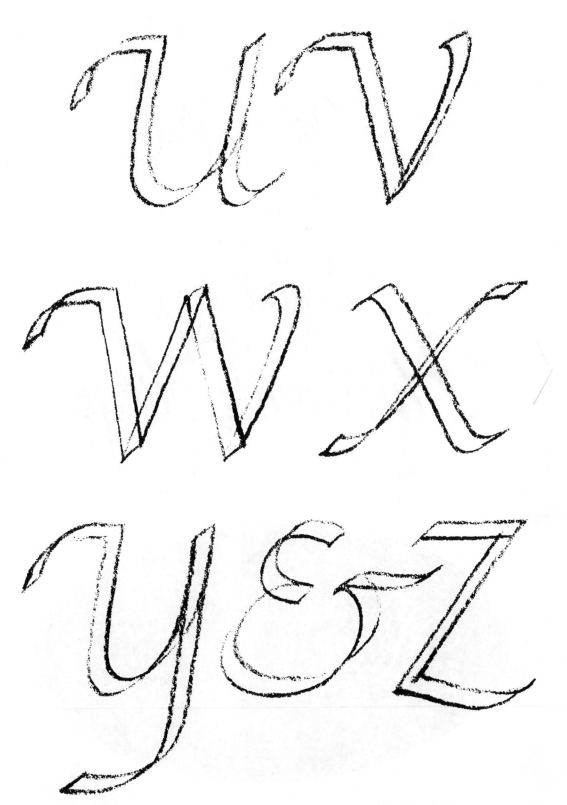

ITALIC LOWER CASE REFINED FORMS DRAWN WITH TWIN PENCILS

MISCELLANEOUS SPECIMENS

This we know,
all things are connected,
 like the blood
which unites one family.
 All things are connected.
Whatever befalls the earth,
befalls the sons of the earth.
Man did not weave the web of life;
 he is merely a strand in it.
Whatever he does to the web,
 he does to himself.

CHIEF SEATTLE OF THE DWAMISH TRIBE

MISCELLANEOUS SPECIMEN

MISCELLANEOUS SPECIMENS

For so work the honey bees,
Creatures that by a rule in nature teach
The act of order to a peopled kingdom.
They have a king and officers of sorts:
Where some like magistrates,
correct at home,
Others like merchants, venture trade abroad,
Others, like soldiers, armed in their stings,
Make boot upon the summer's velvet buds,
Which pillage they with merry march
bring home
To the tent-royal of their emperor;
Who, busied in his majesty, surveys
The singing masons
building roofs of gold,
The civil citizens
kneading up the honey,
The poor mechanic porters crowding in
Their heavy burdens at his narrow gate,
The sad-eyed justice,
with his surly hum,
Delivering o'er to executors pale
The lazy, yawning drone.
Shakespeare
Henry V

MISCELLANEOUS SPECIMEN

Though the youth
at last grows indifferent,
the laws of the universe
are not indifferent,
but are forever
on the side
of the most sensitive.

THOREAU

MISCELLANEOUS SPECIMEN